Spectres: When Fashion Turns Back

*

Spectres: When Fashion Turns Back

*

Victoria and Albert Museum
ModeMuseum Antwerpen

Contents

Victoria and Albert Museum

PREFACE BY SANDRA HOLTBY, HEAD OF LONDON COLLEGE OF FASHION, AND MARK JONES, DIRECTOR, V&A

When London College of Fashion and the Victoria and Albert Museum jointly created the post of Research Fellow in Contemporary Fashion in 1999, both institutions were signalling their continuing commitment to innovative research, design, learning and curation in the field of modern fashion.

The appointment of Judith Clark as the second incumbent of the Fellowship in 2002 brought new dimensions and new collaborations to the project. Judith was already widely respected as an independent curator whose original ideas and practical skills situated the work of contemporary fashion designers in extraordinary new contexts. We knew that she would challenge existing preconceptions and ways of doing things in both the College and the Museum. Judith's existing association with Antwerp's enterprising ModeMuseum also opened up a dialogue between the experimental and avant-garde fashion practices for which Belgium has become famous, and the equally edgy, street-influenced fashion culture of London with its longer historical roots.

This publication and its associated exhibition draw explicitly on both of these themes, relating the forward-looking outputs of recent generations of designers to a longer 'fashion memory'. They bring together past and present in a fascinating scenario where influences, recollections and shadows combine to form a visionary landscape that is as close to the sensations of the nineteenth-century fairground as it is to current trends in museum display. The publication itself also develops the concept of the exhibition book. It avoids the polished summary in favour of a more open 'work-in-progress' compilation of views and ideas. In its vivid presentation of the research processes and conversations that underpinned the curatorial work, we hope that this volume will provide students, designers, exhibition visitors and interested readers with the creative stimulation that Judith has offered to those with whom she has worked along the way. Creative stimulation is after all a key concern and duty of the museum and the design college and a defining characteristic of twenty-first-century fashion.

*

ModeMuseum

PREFACE BY LINDA LOPPA, DIRECTOR, AND KAAT DEBO, CURATOR

Malign Muses: When Fashion Turns Back is MoMu's fifth exhibition and our first collaboration with curator Judith Clark, the Victoria and Albert Museum and London College of Fashion. We became acquainted with Judith during the 'lAnded-gelAnd' project. Since then, she has been a witness to MoMu's first steps and to the path that we have embarked on since the opening in 2001.

For the catalogue of our first exhibition, *The Fashion Museum: Backstage,* we asked Judith to write a statement about the idea of the 'museum of fashion' and the aspect of 'curating dress' in particular. What we received was a manifesto which comprised the entire concept underlying *Malign Muses* and which revealed a well-framed and deeply drawn concept of history.

Looking back at our exhibitions, 'history' has never been absent, nor was it ever evident or unproblematic. It is perhaps one reason why we have thus far not undertaken a permanent exhibition of our collection, for how does one present a collection in a linear or cyclical context? Can a curator allow herself not to deal consciously with history?

Walter Benjamin, whose thinking runs through *Malign Muses*, developed a concept of history that appears to suit the continuity of the circular model. But paradoxically, this circle is dominated by the breach, by the interruption or the shock, so that the beginning and end don't simply fall into place. It is thinking dominated by a tension in which the restorative, the return to the historical, has already born within it the shoots of the new and the revolutionary.

Each time, it is a challenge to let visitors discover what is yet to be by way of seeing what has been, by asking questions rather than giving answers. We have tried to do this in themes and exhibits in which a new language of form is developed. It is intensive work that demands a great deal from the entire museum team, but which we hope guarantees a certain openness, inviting each visitor to set out a course of his or her own.

Judith gives content to the phenomenon of 'curator' in an exhibition with an exceptionally open structure. She provides us with no neatly defined answers, but speaks of 'suggestions', of possible ways to exhibit dress. The first installation is a labyrinth in which the viewer, by way of peepholes, discovers a structure connecting the articles of clothing. The back, however, offers a deceptive overview of the labyrinth, for it both demystifies and catapults us back into the chaos of history. Judith has borrowed the spatial metaphor of the labyrinth from Walter Benjamin, among others, and in turn uses this as a way of 'looking' at history. The image of the labyrinth reminded Benjamin of embroidery. The clearer the pattern on the front of the piece, the larger the clumps of threads at the back. In a single movement, with each step forward, twice as many questions are raised. A curator's work can be likened to such embroidery. Unravelling the web of history is a stimulating task, one not to be underestimated and often frustrating.

Judith, thank you for your courage in entering the labyrinth of *Malign Muses*. It was a captivating exploration for all those whom you have succeeded in inspiring with the muses and the passions that are your own.

*

Spectres: *When Fashion Turns Back*

CHRISTOPHER BREWARD, BASED ON AN INTERVIEW WITH JUDITH CLARK, CURATOR

This is a book that, like the two exhibitions it documents, challenges simplistic assumptions about the nature of fashion and the related role of the art and design museum. In both of these important fields of contemporary cultural practice, audiences have become used to witnessing the polished results of months and sometimes years of planning and preparation as fashion assumes a more dominant role in exhibition schedules and the production of glossy publications. Yet, as outsiders to the rather closed worlds of design and curation, readers of the fashion page, consumers of spectacular garments and visitors to the gallery are often left unaware of the complex stories, developments and negotiations which lie beneath the shimmering final show. In the language of fashion presentation, the flawless surface too easily becomes the prime objective – sometimes to the detriment of a deeper understanding. *Spectres*, therefore, sets out to reveal the shadows and traces whose hidden and sometimes menacing presence adds meaning to certain traditions of contemporary dress, and whose role is most effectively demonstrated through the medium of the fashion display. It sets out its evidence as a form of 'work in progress', whose constituent parts help to sketch out crucial ideas concerning collaboration and creativity. For both the exhibition and the book address the related themes of influence, historical connections and genealogies that continue to haunt avant-garde designers and cutting edge curators, united as they both are by a central concern with the rather terrifying idea of the muse, or patron for new artistic and intellectual departures – the 'malign muse' to which the title of the Antwerp version of the exhibition makes reference.

At the core of the project sits an enterprising relationship which has developed between three very different institutions and the creative vision of one pioneering individual. For the past five years, London College of Fashion and the Victoria and Albert Museum have supported a full-time Fellowship in Contemporary Fashion, whose brief is to explore the possibilities raised by research into contemporary dress from the theoretical and practice-based perspectives of the art and design college and the curating and display interests of a national museum. As the second incumbent of the Fellowship, Judith Clark came to the position with an impressive track record as an independent fashion curator. Trained in Architecture at the Bartlett School of Architecture and the Architectural Association, London, Clark gradually 'defected' from the world of building, seeing in the dressing of bodies a potent parallel with the dressing of space. These ideas were first tested in the production of a short film, shown at the Architecture Foundation, London, in 1997, based on a hypothetical exhibition *Satin Cages*, where miniature crinolines were shown suspended in a balsa-wood framework, echoing a visionary project by Russian architects Brodsky and Utkin. In an uncanny suggestion of future developments, the miniaturised exhibition leaflets featured in the film mimicked those produced by the Victoria and Albert Museum.

Clark's unique take on the display and interpretation of fashion was further demonstrated through a series of innovative exhibitions and installations held from

1997 until 2002 at her own gallery (Judith Clark Costume) based in London's Notting Hill. From the inaugural show of craftsman Dai Rees's unearthly hats, accompanied by the publication of a visual essay produced by the artist Mat Collishaw, through the exhibit *Captions*, which explored the subjective responses of many viewers to the display of an Alexander McQueen dress, to reflections on object types such as *Capes*, thematic shows including *Frills and Flounces* (on Englishness in dress) and *The Garden*, and scholarly reviews of iconic designers such as Vionnet, Clark's work there consistently questioned the values of established disciplinary boundaries between the categories of art, history and fashion and offered visually stunning display solutions. Her growing reputation as an innovator brought her to the attention of the Fashion Museum (ModeMuseum), established in Antwerp in 2002, and resulted in her contribution of a polemical statement on curation to its first catalogue, *Backstage*, and a commission to produce the exhibition *Malign Muses – When Fashion Turns Back*, whose intellectual and practical evolution is documented in this book. In her published reflections for *Backstage*, Clark made two prescient comments. The first suggested that 'historical reference in dress has never been about evolution, continuity. There are other ways of plotting this. In dress, surfaces float free of their histories… Curating is like creating a new grammar, new patterns of time and reference… Unlike language, but more like the multiple meanings of a pack of tarot cards, objects can be read back to front and side to side.' The second asked 'What would it be like to be the Laurence Sterne of fashion curators, to be free to lose the thread?' *Malign Muses* is in many ways a physical version of the first comment and an intriguing answer to the second.

<p style="text-align:center">*</p>

Dialogue

Collaboration has always been an important aspect of Clark's curating practice, and she states that the best fashion exhibitions are often the outcome of fertile conversations. The first important conversation situated at the heart of *Malign Muses* is that which has taken place over the past two years between Clark and British fashion theorist Caroline Evans. Evans presents her own account of the further reflections their discussions inspired in an essay for this volume, but it is worth outlining here the impetus that set it going in the first place. Both Clark and Evans were participants in a large Arts and Humanities Research Board-funded project on the relationship between fashion and modernity, involving theorists, historians and designers from Central Saint Martins College of Art and Design and London College of Fashion. At one of its early seminars Evans presented some of the ideas that would go on to inform her 2003 book *Fashion at the Edge: Spectacle, Modernity and Deathliness*, where 'in order to think about fashion time, and how it operates in a non-linear way' she 'used a number of spatial metaphors, many of them drawn from Walter Benjamin's writing… such as the labyrinth, the telescope, the diorama, and the tiger's leap'. Clark had originally come to the project with a related idea for an exhibition on fashion genealogies, tentatively titled (from Borges) Garden of the Forking Paths, but Evans's presentation opened up a much wider arena in which theoretical musings vividly suggested curatorial and architectural analogies. Clark was excited by the prospect of translating what were essentially text bound and abstract concerns (representations) into three-dimensional form. In a deliberate and sanctioned 'pirating' of Evans's concepts, Clark's interventions went beyond a simple illustration of the ideas in *Fashion at the Edge*, exploring the notion of the exhibition as a parallel narrative that would develop its own momentum and integrity.

The contribution of Russian architect Yuri Avvakumov to the project ensured that Clark's narratives found physical expression in the scaffold-like structure of the exhibition. Avvakumov, who graduated from the Moscow Architecture Institute in the early 1980s, enjoys a reputation as the inheritor of those visionary schemes associated with the Russian Constructivist movement of the early twentieth century. His work was of particular interest for Clark, whose awakening to the links existing between fashion and architecture emerged during the writing of her student thesis on theatre director Vsevolod Meyerhold and his commissioning of sets which are now acknowledged as a key to understanding Constructivist architecture. Avvakumov was the dominant participant in the so-called *Paper Architecture* projects published during the late 1980s while Clark was at her studies. The project focused on un-built hypothetical designs which broke free of the theoretical doctrines of the historical avant-garde. These replaced Utopia with fantasy and caprice. They drew attention to the creative freedom inherent in conceptual design and have been described as being closer to illustration for fiction than to traditional architectural drawing.

References to *Paper Architecture* thus pepper the research section of this book. Between the work of Meyerhold and Avvakumov, Clark could see the exciting potential of designing an exhibition space that suggested the aesthetic imperatives of Constructivist theory, freeing up room for objects to communicate with each other and utilising flat planes of decoration in a theatrical idiom. Avvakumov was thus invited to London for a three-day conversation, which allowed for a careful scrutiny of the floor plans of the ModeMuseum and the Victoria and Albert Museum and prompted the finalisation of a skeletal display scheme which made full use of vertical and horizontal relationships to form the routes and vistas which would 'enact' Evans's space/time metaphors. These ideas are also explored in the essay 'LES, LEST, LET and FLYing ProLETarian*', which Avvakumov has written for inclusion in this book. Like his design concepts, Avvakumov's words forge connections with a visionary style of thought and action redolent of the creative spirit of the Russian avant-garde. Their unique reflections are thus entirely appropriate for a project which aims to challenge the reductive logic of much contemporary fashion writing and display.

Against Avvakumov's framework, Clark has set flat pieces sourced from fashion illustrator Ruben Toledo. Cuban-born Toledo, who works closely with his wife and muse, the designer Isabel, has attracted a cult following for his instinctual and fluid drawings. His ornate and witty commentaries on the vagaries of metropolitan style have provided the perfect foil to the archly elaborate vision of the late fashion curator Richard Martin via the production of murals for a Costume Institute exhibition on the shifting waistline in dress, and the joint authoring of the celebrated *Style Dictionary*. He has also produced work for *Visionnaire, Vogue, Harper's Bazaar* and the *New York Times*. Inspired by Toledo's ability to quote from the history of fashion without reducing his images to simple reproductions, Clark wrote to the illustrator outlining the themes of *Malign Muses*, and he responded with a visual essay which is reproduced in this book. Clark then commissioned him to produce scaled-up pieces for the show, their clever visual quotations forging analogies with the work of the featured designers and the conceptual premise underlying their display.

Framed by the setting which had evolved from Clark's dialogue with Avvakumov and Toledo, the embodied presence so crucial for any presentation of fashion was

orchestrated through further collaboration with British jeweller Naomi Filmer. Clark had previously featured her work in the Judith Clark Costume Gallery exhibit of 1999, *be-hind be-fore be-yond*, in which Cocteau-esque hands emerging from the walls were dressed with slowly melting ice-pieces. For *Malign Muses*, Filmer's interest in prosthetics and the mechanics of installation, honed during experience as a stylist/collaborator for fashion shows by designers such as Alexander McQueen, Dai Rees, Shelley Fox, Tristan Webber, Julien Macdonald and Hussein Chalayan, finds a natural resolution. Her explicit role has been to engage with the Stockman mannequins upon which Clark has dressed the garments. Filmer's interventions make surreal suggestions which move beyond mere styling. Limbs are flocked or oxidised and strange additions are carved or appended. In Clark's words, they are placed like six jewels through the exhibition, inviting the viewer to examine the displays more closely, forming points of connection and intensity. Rather than aid the illusion of a mis-en-scène, Clark and Filmer have been conscious of the need to encourage scrutiny and boldly guide the path of vision. In this sense, the design of *Malign Muses* proposes what Clark terms a 'pure museology'.

Finally, Clark's journey towards the staging of the exhibition was informed by a more diffuse, or virtual, dialogue with the work of celebrated fashion editor Anna Piaggi. Her famous 'double pages' for Italian *Vogue*, with their startling juxtapositions of cut-outs, found-images, drawings and typographical comment, which seem to distil the zeitgeist, had long inspired Clark, and both *Malign Muses* and this book are something of an homage to Piaggi's unique approach. The editor's pairings of contemporary and historical references in collages which eschew sentimentality and nostalgia for a more radical compression of past and present, clearly present a graphic equivalent of curating practice. For Clark, their rough 'mood-board' immediacy and 'parlour-game' charm lend themselves as ideal models for further conceptual and practical elaboration. In her own words, they become 'visual epigrams for thinking about dress'.

<div align="center">*</div>

The Exhibition and the Book

The influences and collaborations that guided Clark towards *Malign Muses* were not simply means to an end. The exhibition itself stands as a record of the development of a concept. It is very much an exhibition about the process of research rather than a simple outcome, and the fact that its objects were selected during the final stages, in a reversal of the usual museum procedure, is testament to its radical intent. This is not to undermine the importance of the garments on show. The diverse list of featured designers includes many of those who have been in the vanguard of conceptual fashion during the past twenty years. Designers such as Junya Watanabe, Dries van Noten, Viktor & Rolf, Angelo Figus, Simon Thorogood, Hussein Chalayan, Shelley Fox, Rei Kawakubo, Hamish Morrow and Russell Sage take their place alongside historical pieces from, amongst others, Schiaparelli, Madame Grès, Jean Dessès, Pierre Cardin, Dior and Mary Quant. But their incorporation into a compelling narrative means that arising pairings and quotations dispel the effect, often prioritised in fashion exhibitions, of presenting a series of 'star' dresses, favouring instead a continuum of relationships.

Old and new items are thus placed together in a sequence of thematic sections titled 'Reappearances: Getting Things Back' (where the concept of historical experimentation is introduced), 'Nostalgia' (questioning the status of imagined pasts and lost futures), 'Locking In and Out' (where huge cogs suggest the clicking together

of past and present), 'Phantasmagoria: The Amazing Lost and Found' (highlighting the fantastical elements of historical quotation), 'Remixing It: The Past in Pieces' (the most explicit reference to Piaggi's collaging effects), and 'A New Distress' (where the fading garments of history morph into contemporary experimentation). In Antwerp, a coda section titled 'Garden of the Forking Paths' takes us back to Clark's original idea of an endless genealogy, here taking the flower motif as the linking clue. The sense of the whole is perhaps most closely related to the nightmarish world of Victorian circuses, fairgrounds or pantomimes, with their transformation scenes, freak show curiosities and lantern-slide tricks. As Clark comments, *Malign Muses* is 'a way of describing a relationship between fashion and its history. It is about quotation, about history as muse and the problematic relationship with repetition, which if read psychoanalytically can be associated with re-enacted trauma. Each section alludes to games, toys, puzzles and rides and their tendency to distort.' Its imagery, like the clothing at its core, is intended to haunt the viewer.

In this book we are privileged to be shown the working documents which contributed to the making of *Malign Muses*, and the reflections of some of those who were involved in its development. Both projects raise important questions about fashion scholarship and curating in visual and written forms, questions that Clark feels are often omitted from the celebratory designer retrospectives and pretty catalogues which too often pass for analysis in the museum and publishing worlds today. She is adamant that fashion displays should not simply be a matter of glamourisation, but that the curator has a duty to explain, to demonstrate the development of ideas, and in believing this she knows that she probably goes against the grain. Her research has thus taken her further away from an uncritical fashion literature and towards a reading of histories of the museum and collections, perception theory and architectural treatises. This striving for new terrain informs such questions as 'how fiercely can we edit objects?', 'what does historical veracity mean?' and 'is there a violence in the decontextualising tendencies of quotation and display?'. *Malign Muses* and its accompanying book go some way towards providing answers, revealing in the process the darker side shared by a recent generation of designers, stylists and indeed curators. But as Laurence Sterne, one of Clark's heroes, so famously stated: 'That's another story.'

*

Research: A Repertoire of Repetitions

*

… a life as an idiosyncratic repertoire of repetitions; and the account of the life always already ironised by the Freudian knowingness of the narrator. The details of a life, of course, can never be predicted; nor can the content or the exact working of the repetitions … But what can be assumed is that there will be repetitions, and that these repetitions found their initial (and initiating) forms in childhood … Our lives may be turbulent, but it is a patterned, if not actually a structured turbulence.

'Childhood Again', in *Equals*, Adam Phillips, Faber & Faber, London, 2002

Reappearances: Getting Things Back

There are clearly many ways of describing and illustrating how the past shows up in the present. This project looks at what happens when you map contemporary fashion, and importantly contemporary fashion theory, onto the history of dress; to look at the ways in >

Arthur Batut, *Child Members of the Family of Arthur Batut,* 1890s. Superimposed photographs. **>p.52**

Anon., *Album of Spirit Photographs: Medium and a Child Ghost,* ca 1901. Gelatin silver print.

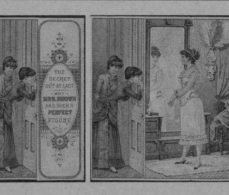

Anon., *The Secret is Out at Last,* c. 1890. Coloured lithograph. **>p.142**

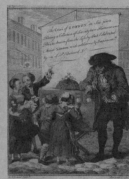

Ravenet after Louis Philippe Boitard, *Oh. You Shall See Vat You Shall See,* 1760. Hand coloured engraving.

…The showpiece is ghostly or spectral. Worn once for just a few seconds by the model on the catwalk, after its disappearance the memory of it can fade slowly, like a retinal image after the real object has gone.

The word 'spectacle' designates a sight or show; the spectre a ghost or vision. Etymologically they have the same root, both coming from 'specere', the Latin verb 'to see'…

Fashion at the Edge: 47, 50

fashion show and she transformed it through its interaction with her own body, making it into a performance piece: the musician Bjork wore it on stage in a concert where, as she danced, the tinkling of the glass plates against each other was amplified and incorporated into the music, turning the dress itself into a percussion instrument.

Thus the showpiece exemplifies the way in which *so* much contemporary fashion enters the realm of the commodity and circulates obliquely, not always as an embodied practice but, sometimes, as an image, an idea, or a conceptual piece. It is in this sense too, that the showpiece is ghostly, or spectral. Worn once for just a few seconds by the model on the catwalk, after its disappearance the memory of it can fade slowly like a retinal image after the real object has gone. Only the photographs that recorded its brief appearance testify that it was really there. *In* Antonio Berardi's Spring/Summer 1998 *Autumn/Winter 97* Voodoo collection shown in London's RoundHouse, models with dishevelled hair and dirty faces danced round a fire to the accompaniment of Techno music and live African drumming. One in particular acted 'spooked', nervy but trance-like. The show *was* accessorised *e included* with celestial candleholders with burning candles shaped into a crown, worn on the head, with shells and feathers plaited into long braids. But, as in many fashion shows, the dramatic show pieces which animated the spectacle were never put into production, and the collection which appeared in the shops was less spectacular, but more wearable.

The word spectacle designates a sight, or show; the spectre a ghost, or vision. Etymologically they have the same root, both coming from *specere,* the Latin verb 'to

(Throughout this section): Original manuscript pages of *Fashion at the Edge: Spectacle, Modernity and Deathliness,* Caroline Evans, Yale University Press, London and New Haven, 2003

which the past haunts and foreshadows the present. In these six excerpts from possible genealogies, in these unexpected combinations of images and disciplines, we can browse for clues about exhibiting dress. And what else might we be suggesting when dress is displayed?

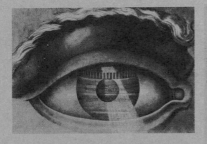

Claude Nicolas Ledoux, *The Eye. Theatre Interior*, 18th century engraving.

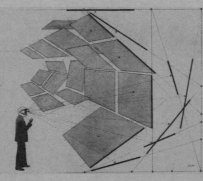

Herbert Bayer, *Diagram of Vision*, 1930.

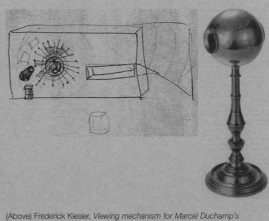

(Above) Frederick Kiesler, *Viewing mechanism for Marcel Duchamp's Boite-en-valise* (1935-41), 1942. Vintage gelatin-silver print.
(Above right) Model of the eye. Attributed to Benjamin Martin (English, act. 1738-77), about 1765. Brass and glass.

Although there is no repetition without difference, nevertheless the conditions of post-industrial modernity are haunted by those of industrial modernity when fashion designers dip into the past for their motifs and themes. These traces of the past surface in the present like the return of the repressed. Fashion designers call up these ghosts of modernity and offer us a paradigm that is different to the historian's paradigm. Like nineteenth-century rag-pickers, or late twentieth-century DJs, they remix fragments of the past into something new and contemporary that will continue to resonate into the future. They illuminate how we live in the world today, and what it means to be a modern subject.

Benjamin described how he once drew a diagram of his life as a labyrinth. The metaphor of history as a labyrinth allows the juxtaposition of historical images with contemporary ones; as the labyrinth doubles back on itself what is most modern is revealed as also having a relation to what is most old. Thus distant points in time can become proximate at specific moments as their paths run close to each other.

Fashion at the Edge: 9

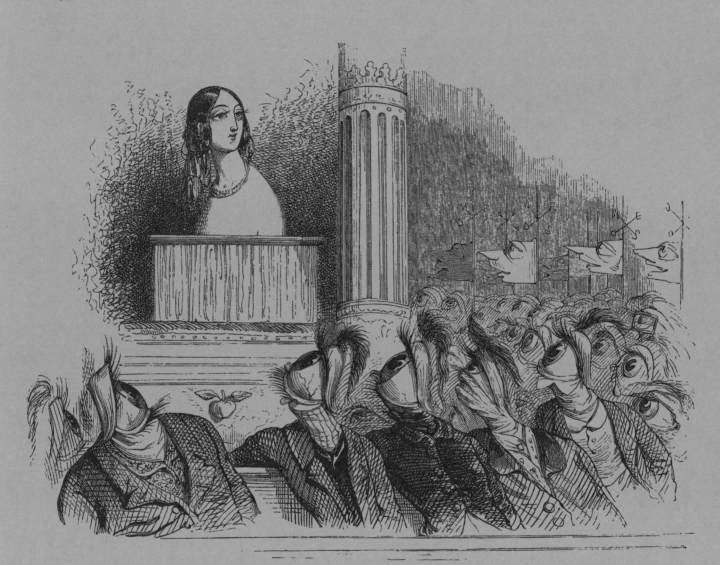

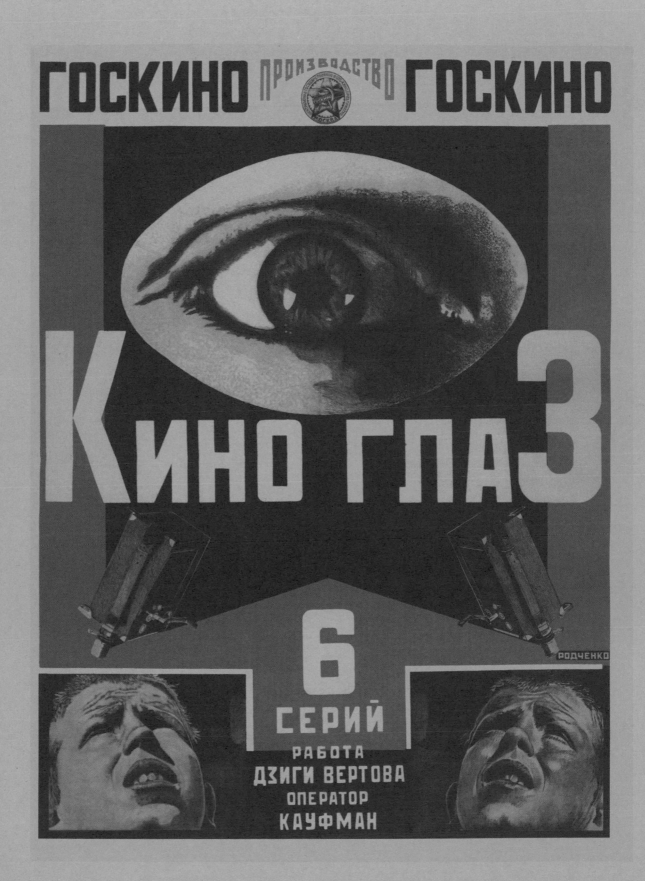

In this section, which includes optical devices, labyrinths and instruments to manipulate distance, the exhibition considers what we are doing when we look at the past and how our looking might be visualised. Each of these objects both aid and distort the ways we look back. >

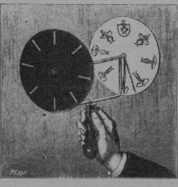

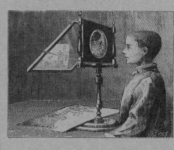

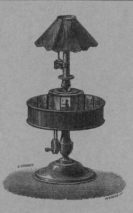

Reynaud's praxinoscope. Engraving by Chauvet in *La Nature*, 1879.

Plateau's phanakistoscope. Engraving by Poyet in Gaston Tissandier's *Popular Scientific Recreations* (London, 1885).

Optical apparatus. From *La Nature*, 1886.

Reynaud's praxinoscope. Engraving by Gilbert in *La Nature*, 1880.

If late twentieth-century fashion looped back to earlier moments of modernity in specific formations, it was not because the moments of past and present were the same but because a visual link between them uncovered interesting things about the present that echoed the past. Fashion designers can elucidate these connections visually in a way that historians cannot do without falsifying history. For designers, it is precisely through the liberties they take that contemporary meaning can be constructed.

All history is written about from the perspective of the present, in the sense that the present throws up themes to be studied historically. Since the present is always in a state of transformation, the past must constantly be re-evaluated.

Fashion at the Edge: 11, 12

17

certainties without heralding in new ones, in much the same way that new scientific discoveries in the sixteenth century brought attendant uncertainties. Jonathan Dollimore has argued that cultures which are preoccupied with mutability are cultures of transition in which all fixed points seem to have been removed.[40] He cites a range of causes in the sixteenth century that produced a sensibility attuned to dislocation and disintegration, from the invention of mechanical time, in the form of the clock, to the ideas of Copernicus, Kepler and Galileo, whose scientific speculations infinitely extended the idea of mutability to produce a philosophical, theological and literary conviction that the universe was in a state of decay and decline.[41] As a modern corollary, one could point to the impact of new technology on contemporary sensibilities, even though there are differences of scale as well as meaning between a hierarchical, early modern society and a mass, or popular, late modern society. From the 1980s Sony Walkmans, mobile *tele-* phones, *CCTV closed-circuit television* cameras, emails, videos, new medical and scientific imaging techniques, and other technological novelties altered the experience of space, time and the body, changed the notion of privacy and affected work and leisure practices in varying ways that seemed, to some, exhilarating and, to others, profoundly destabilizing.[42]

Ragpicking } Sub-heading

If late twentieth-century fashion looped back to earlier moments of modernity in specific formations, it was not because the moments of past and present were the same but because a visual link between them uncovered interesting things about the present that *had echoed in* the past. Fashion designers can elucidate these connections visually in a way that historians cannot do without falsifying history. For designers, it is precisely

17

We are always rooted in our point of view, looking from somewhere in particular with a purpose in mind. Looking always transforms what it sees.

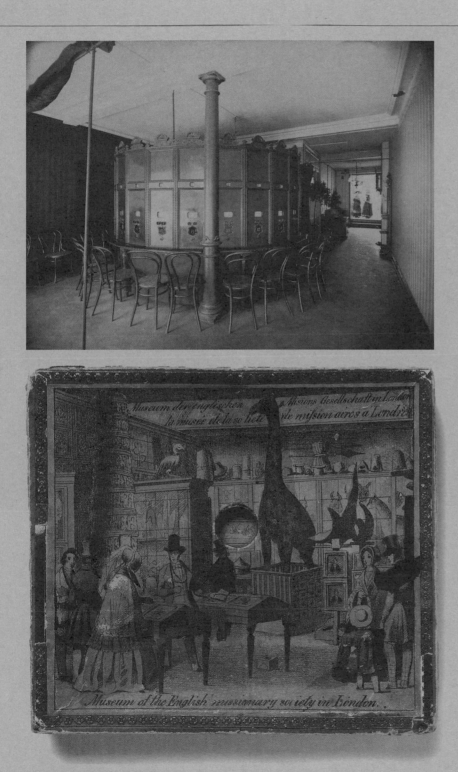

Nostalgia

Nostalgia is satisfying because it is a longing for a past that never existed and for a future that can never be. As a fantasy you can make the past any way you want to. >

Etienne-Louis Boullée, *Interior view of the new projection room for the enlargement of the bibliothèque du Roi*, 1785.

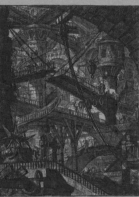

Giovanni Battista Piranesi, *Carcere, with Numerous Wooden Galleries and a Drawbridge (second state)*. From *The Prisons (Le Carcieri)*, ca. 1745.

Alexander Brodsky and Ilya Valentinovich Utkin, *Dome*, 1989-90. Etching. **>p.124**

Alexander Brodsky and Ilya Valentinovich Utkin, *The Intelligent Market*, 1987-90. Etching.

If we overlay ... experimental forms with shadows from a previous moment of commodity culture we can see traces of earlier reified, technologised and fetishised bodies. It raised the bigger question of how a late twentieth-century designer might draw on the aesthetic and language of early twentieth-century modernism, even though the historical conditions that gave rise to the early optimism and utopianism of modernism were long gone, without falling back on a contemporary sense of cynicism and ennui, or on millenarian visions of apocalypse.

Fashion at the Edge: 274-5

suggestive possibilities, shadowed by history and time. It raised the ~~bigger~~ question of how a late twentieth-century designer might draw on the aesthetic and language of early twentieth-century modernism, even though the historical conditions that gave rise to the early optimism and utopianism of modernism were long gone, without falling back on a contemporary sense of cynicism and ennui, or on millenarian visions of apocalypse.

New Technology [Sub-heading]

~~One xreme explored by some designers was to look optimistically for the future~~ Several Japanese ... explored

Some designers explored the possibilities of new textiles technology. Whereas ~~a designer like~~ Shelley Fox used labour-intensive and pre-industrial craft techniques in her ~~use~~ treatment of felting, ~~many Japanese~~ ~~designers such as~~ and selected Issey Miyake reversed this process, using advanced textile technology to create fabrics that looked labour-intensive, as well as innovative, such as holographic cloth.[20] Miyake developed his A-POC concept in collaboration with the textile engineer Dai Fujiwara, ~~that~~ which was first produced in 1999.[21] Short for 'a piece of cloth', the A-POC was a bolt of cloth in bright green, scarlet, white or navy from which the purchaser could construct their own wardrobe. Constructed from raschel-knit tubes produced from computer-programmed industrial knitting machines, the fabric did not require stitching when cut. The A-POC was patterned with a series of serrations, rather like the lines on a traditional paper pattern. The owner chose from a range of possible garments and cut out and constructed their own garment. The options included a dress, either full or three-quarter length, with either short or three-quarter length sleeves, or sleeves that extended

Nostalgia and a sense of impossibility go together. For the nostalgic, the repertoire is infinite in the quest to keep pleasure alive. In fashion, a monument can only ever be a monument to a moment.

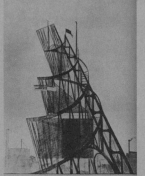

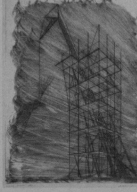

Vladimir Tatlin, *The Monument to the Third International*, Sketch of the inclined axis. 1919.

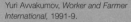

Yuri Avvakumov, *Red Tower*, Moscow, 1987 (edited 2004). **>p.126**

Yuri Avvakumov, *Worker and Farmer International*, 1991-9.

Ljubov Popova's theatre set design for Vsevolod Meyerhold's 1922 production *The Magnanimous Cuckold* (written by Fernand Crommelynk).

p. 265 A

Fashion and textile design that was driven by the possibilities of new technological processes recalled the way that modernist designers earlier in the century experimented with utopian ideas, speculatively mapping the future through imagined technological Utopias, resolutely turning their backs on the past. By the end of the century, however, for a designer to fetishise technological progress and novelty suggested a double ghosting: a return to heroic modernism that refused the sedimentation of history, seeking to expunge the insistent past-in-the-present of modernity.

This denial haunted the work of a range of designers who explored the possibilities of new technology or new types of clothing.

↪ run on to 'Some designers . . .'

Fashion and textile design that was driven by the possibilities of new technological processes recalled the way modernist designers earlier in the century experimented with utopian ideas, speculatively mapping the future through imagined technological Utopias, resolutely turning their backs on the past. By the end of the century, however, for a designer to fetishise technological progress and novelty suggested a double ghosting; a return to heroic modernism that refused the sedimentation of history, seeking to expunge the insistent past-in-the-present of modernity.

Fashion at the Edge: 275-6

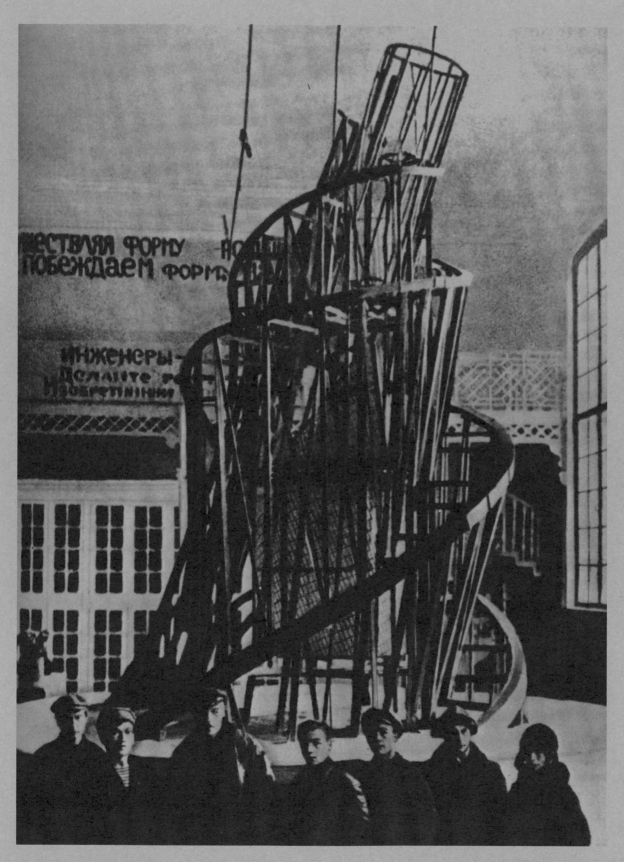

We claim that the nostalgic man, in his attachment to the past, searches for his lost childhood, this mythical time of childhood from where he is henceforth exiled. Yes, no question. But I think that his homesickness has another source. It's not the past that he idealizes; it isn't the present on which he turns his back but on what is dying. His wish: that anywhere – whether he changes continents, cities, jobs, loves – he could find his native land, the one where life is born, is reborn. Nostalgia carries the desire, less for an unchanging eternity than for always fresh beginnings. Thus time that passes and destroys tries to take away the ideal figure of a place that remains. The homeland is one of the metaphors of life.

'Nostalgia' in *Windows*, J.-B. Pontalis, University of Nebraska Press, 2003

(Left) The Tatlin Studio Collective in front of the model of The Monument to the Third International (Tatlin third from left), 1919.

Locking In and Out

Fashion, by definition, has a promiscuous memory; it locks into things and it locks out with surprising speed. Uncanny recognitions and unpredictable conjunctions are integral to the fashion machine. Fashion can't afford to get stuck, but it also can't afford to be predictable. >

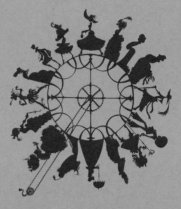

The Power Loom, Dens Works Dundee, 1863. A late-comer to the Dundee linen trade.

M.Edward James Muybridge's Pneumatic Clock. From *La Nature*, 1878.

From *Harper's Bazaar*, Oct 1927.

Ruben Toledo, *Idea for a giant spinning wheel of fashion*, 2003. **>p.123**

The juxtaposition of these images, on the one hand of late twentieth-century fashion shows, and on the other of the merchandising and retail extravaganzas of a century earlier, invokes Walter Benjamin's idea of 'dialectical images'.

Dialectical images were not based on simple comparisons but, rather, created a more complex historical relay of themes running between past and present. The principle of montage is that a third meaning is created by the juxtaposition of two images, rather than any immutable meaning inhering in each image. The flash of recognition between past and present images was the dialectical image that transformed both. Jolted out of the context of the past, the dialectical image could be read in the present as a 'truth'. But it was not an absolute truth, rather a truth which was fleeting and temporal, existing only at the moment of perception, characterised by shock or vivid recognition. It was not that the past simply illuminated the present, or that the present illuminated the past; rather the two images came together in a 'critical constellation' tracing a previously concealed connection.

Fashion at the Edge: 33

42

48

images were not based on simple comparisons but, rather, created a more complex historical relay of themes running between past and present. For Benjamin, the relationship between images of the past and the present worked like the montage technique of cinema.[30] The principle of montage is that a third meaning is created by the juxtaposition of two images, rather than any immutable meaning inhering in each image. Benjamin conceived of this relationship as a dialectical one: the motifs of the past and the present functioned as thesis and antithesis. The flash of recognition, between past and present images, was the dialectical image that transformed both. Jolted out of the context of the past, the dialectical image could be read in the present as a 'truth'. But it was not an absolute truth, rather a truth which was fleeting and temporal, existing only at the moment of perception, characterised by 'shock' or vivid recognition. It was not that the past simply illuminated the present, or that the present illuminated the past; rather, the two images came together in a 'critical constellation', tracing a previously concealed connection.[31]

Throughout the 1990s, conjuring something out of nothing, Galliano could be seen as a master of ephemeral ceremonies, whose essence shares the nature of a ghost, transient, restless, evanescent, whose work is haunted by the excessive displays of conspicuous consumption of consumer capitalism. His nostalgic designs conjured up an earlier period of idleness and luxury, yet the historical period he drew on was also, like the present, a time of mutability, instability and rapid change, when all fixed points seemed to be in motion, and in which the image of woman was correspondingly highly charged. For the image of woman as commodity and consumer was as ambivalently

48

The question is: how does fashion keep unlocking itself?
In this compulsive love affair with the past, the past is alternately familiar and alien.

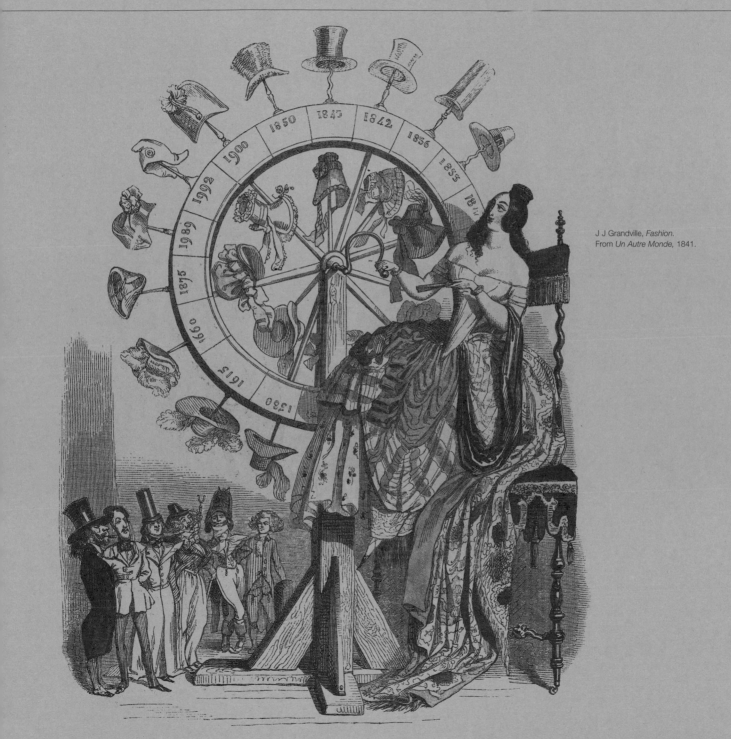

J J Grandville, *Fashion*.
From *Un Autre Monde*, 1841.

Phantasmagoria: The Amazing Lost and Found

In the fantasy past, clothes can be anything we want them to be. In this conjuring of dress, clothes fit the body as a shadow does. The tricks of the circus, the typecasting of the harlequin and the >

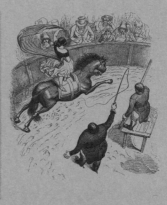

J.Nick, *An Apology to the Town, for Himself and the Bottle*, January 1749.

Carousel, Sea Breeze Park, Rochester, New York. Built by the Philadelphia Toboggan Company, 1915. **>p.143**

Nikolai Ulyanov, *Meyerhold as Pierrot in 'The Fairground Booth'*, 1906. **>p.77**

J J Grandville, *In his flight, Hahblie sees a circus bareback rider.* From *Un Autre Monde*, 1841.

The invisible designer, part-impresario, part-puppeteer, controlled the working of the show from behind the scenes, in a way reminiscent of the department store owner Mouret's Svengali-like behind-the-scenes manipulations in Zola's The Ladies' Paradise, *based on the real Boucicault, creator of the first Parisian department store in 1852, the Bon Marche'.*

Like shop window dummies on revolving podiums.

Fashion at the Edge: 89

114 94

Chapter 4 PHANTASMAGORIA

Magic delusion

Alexander McQueen's runway show for his fourth couture collection for Givenchy (Autumn/Winter 1999/2000) featured draped and cowl-necked devoré dresses, and was staged on a conventional catwalk. Its *coup de théâtre* was to replace the conventional parade of models on the runway by mannequins with clear, plexiglass heads ▮▮▮▮. Springing from trap doors cut into the catwalk, they rotated slowly on wooden disks before sinking back down into the darkness from which they came ▮. The journalist Laura Craik wrote, 'the spectacle was riveting. Never have dummies looked so alive.'[1] Below the stage an elaborate system of scaffolding housed the mannequins and, from this lower world, the designer, too, rose up at the end like Mephistopheles to take his bow, before descending back into the darkness. The invisible designer, part-impresario, part-puppeteer, controlled the working of the show from behind the scenes, in a way reminiscent of the department store owner Mouret's Svengali-like behind-the-scenes manipulations in Zola's *The Ladies' Paradise*, based on the real Boucicault, creator of the first Parisian department store in 1852, the *Bon Marché*.

The previous autumn in Milan, for its Spring/Summer 1999 collection, the design company Etro replaced the conventional runway with a conveyor belt on which the models posed like shop window dummies on revolving podiums, while an acrobat swung overhead. Like a photographic negative and a positive, these two shows made the same essential point: in the Etro show the living models looked like dummies, in the Givenchy show the dummies seemed to come alive. In both, the

114

shape-shifting of the shadow all distract us from history, masking its details. Each in their different ways coerce our attention and stop us thinking about where they have come from and where they might be going.

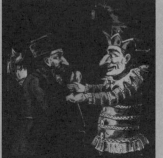

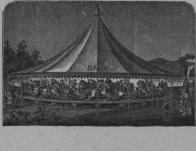

Russian Petrushka, 19th century. Woodcut.

Dare's Steam-powered 'Galloping Horses', commonly known as the 'Tonawanda' type machine. **>p.72**

George Cruikshank, *Punch Hangs the Hangman*. From Payne-Collier's *Tragical Comedy of Punch and Judy*, 1928.

BJ Falk, *Pilar Morin in Clown Costume*, ca. 1895.

115 95

phantasmagoric figures created a bridge between animate and inanimate models, liveliness and deathliness. The term 'phantasmagoria' was first used in English in 1802 to describe another form of popular spectacle. Philipstal's *phantasmagoria* in London consisted of a magic lantern show in which skeletons, ghosts and other fantastical figures were made rapidly to increase and decrease in size in a darkened room veiled with gauze, unexpectedly advancing on the spectators, before finally appearing to sink into the ground and disappear, very like the mannequins in the Givenchy show (see fig. 64). The term *phantasmagoria* thus came to describe back-lit optical illusions, usually those of the magic lantern, and metaphorically it came to connote some form of dramatic visual deception or display, in which shadowy and unreal figures appear only to disappear.[2]

In his analysis of Richard Wagner's operas, Theodor Adorno used the term *phantasmagoria* to designate the tricks, deceits and illusions of nineteenth-century commodity culture, with its sleights of hand that peddled false desires.[3] Since its light source could not be seen by the spectators, the magic lantern provided Adorno with a metaphor for the way in which the working mechanisms of capitalist production were hidden from view by its marketing and retail stratagems.[4] In the same way, the workings of the Givenchy show were concealed below the catwalk, and the audience was distracted by the disconcerting substitution of the inanimate dummy for the living model. The concealed machinery beneath the catwalk was like the commercial transaction, while the ghostly mannequins rising out of, and falling back into, the darkness suggested the phantasmagoria or 'magic delusion'[5] of the dream world. When John Galliano based his autumn/winter 1996 collection on the fantasy that the Princess Pocahontas went to Paris in the 1930s where she met

115

The term 'phantasmagoria' was first used in 1802 to describe another form of popular spectacle … a magic lantern show in which skeletons, ghosts and other fantastical figures were made to rapidly increase and decrease in size … metaphorically it came to connote some form of dramatic visual deception or display, in which shadowy and unreal figures appear…

… the magic lantern provided [Theodor] Adorno with a metaphor for the way in which the working mechanisms of capitalist production were hidden from view by its marketing and retail stratagems.

Fashion at the Edge: 89

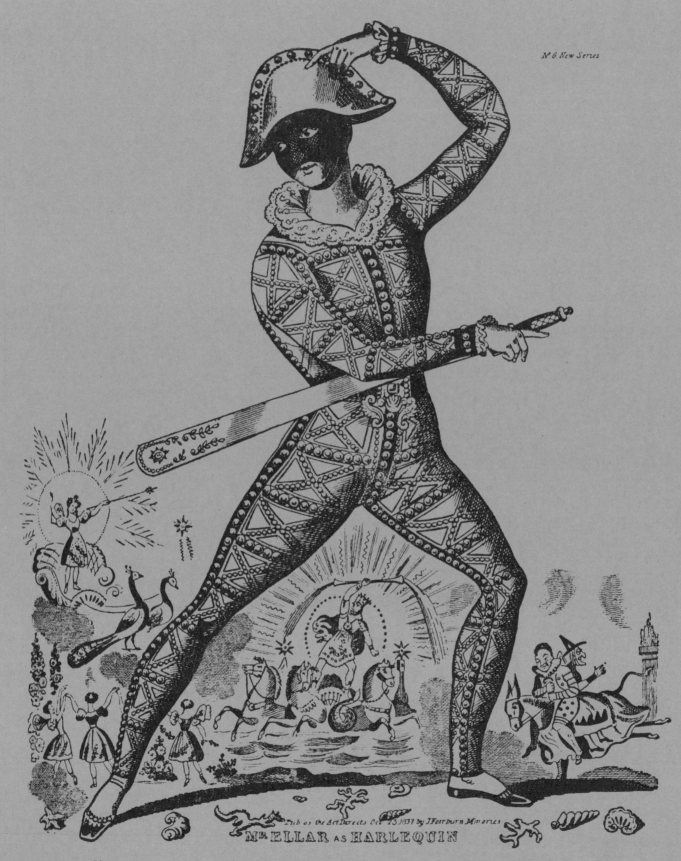

Mʳ ELLAR ᴀꜱ HARLEQUIN

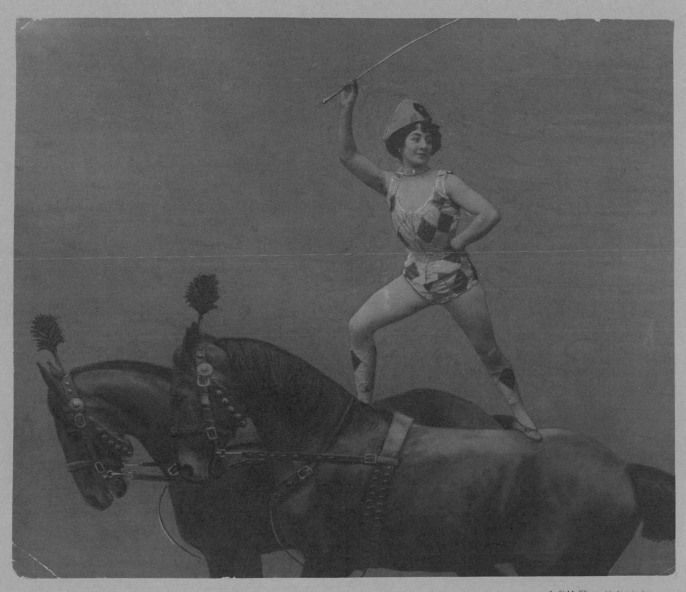

(Left) Mr Ellar as Harlequin. In
Cyril Beaumont's *The History of
Harlequin,* 1926.

(Above) Blanche Allarty with circus
horses, ca. 1890. **>p.78**

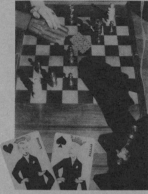

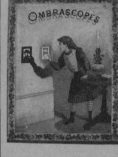

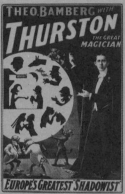

Claude Cahun, *Cards, Chessboard, Hands,* 1930. Photogravure print.

Ombrascopes, ca 1900.

Portrait Silhouettes. From *La Nature,* 1885 **>p.88**

Poster for Theo Bamberg (Thurston) shadows performance, 1910. Lithograph.

Anon. *Danse des sorciers (Dancing Devils).* Engraving in Fulgence Marion's *L'optique,* 1867.

Like a shadow that has lost its body, the model's image recalled Marx's description in 1848 of the revolution in Paris: 'if any section of history has been painted grey on grey, it is this. Men and events appear as inverted Schlemihls, as shadows that have lost their bodies.'

Fashion at the Edge: 43

'Last night I was in the Kingdom of Shadows. If only you knew how strange it is to be there. It is a world without sound, without colour. Everything there – the earth, the trees, the people, the water and the air — is dipped in monotonous grey. Grey rays of sun across the grey sky, grey eyes in grey faces, and the leaves of the trees are ashen grey. It is no life but its shadow, it is not motion but its soundless spectre.'

Maxim Gorky's description of seeing two films by the Lumière brothers for the first time in 1896. Quoted in Fashion at the Edge: 43

51

Chapter 2, HAUNTING } Chapter heading

Shadows } sub-heading

In December 1997 German *Vogue* featured a series of photographs by Inez Van Lamswerde and Vinoodh Matadin of Viktor & Rolf's designs in which the model, 'Missy', her face and hands covered in black make-up, posed in ghostly black on a black ground. Like a shadow that had lost its body, the model's image recalled Karl Marx's description in 1848 of the current revolution in Paris: 'if any section of history has been painted grey on grey, it is this. Men and events appear as inverted Schlemihls, as shadows that have lost their bodies.'[1] In the story by Chamisso, Peter Schlemihl sells his shadow to the devil, in exchange for a magic purse, with the consequence that, amongst other things, he can no longer leave the shade for the sunshine.[2] In the *Vogue* photographs Viktor & Rolf's ghostly model appeared as an inverted Schlemihl who had cut herself off from the world of embodied corporeality and who existed solely as a shadow.

In spring 2001 the designers reprised this idea and made their photographic vision real on the catwalk, by sending out the models in their Autumn/Winter 2001/2 ready-to-wear collection dressed entirely in black into a darkened salon on a plain white catwalk, their hands and faces painted as black as their clothes. At the end of the show the two designers took their bow, also silhouetted in black. When, at the finale, all the models paraded back together like an army of disembodied shadows, the effect was to transform the normally vibrant and colourful fashion show into a simulacrum of black

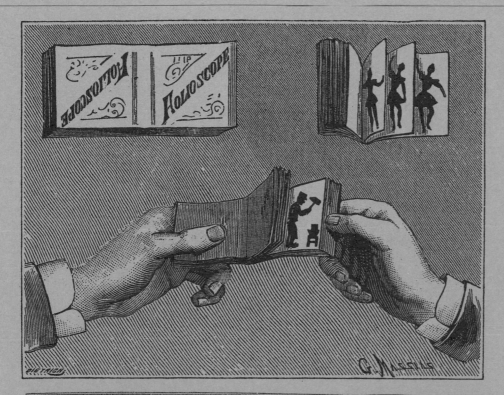

(Left) Folioscope. From
La Nature, 1898.

(Below left) Lavater's machine for
making silhouettes (after an old
engraving from 1783). From
La Nature, 1892.

(Following page left) McLaughlin
Bros., *Gyrating Shadow Lantern*,
1875. Mixed media.

(Following page right) Ruben
Toledo, *The Magic Lantern of
Fashion*, 2004. **>p.120**

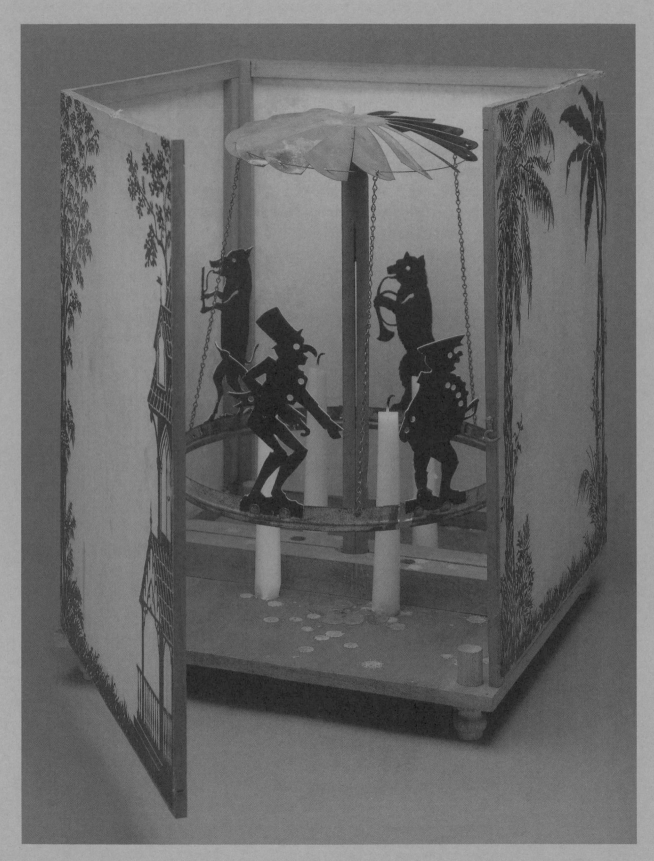

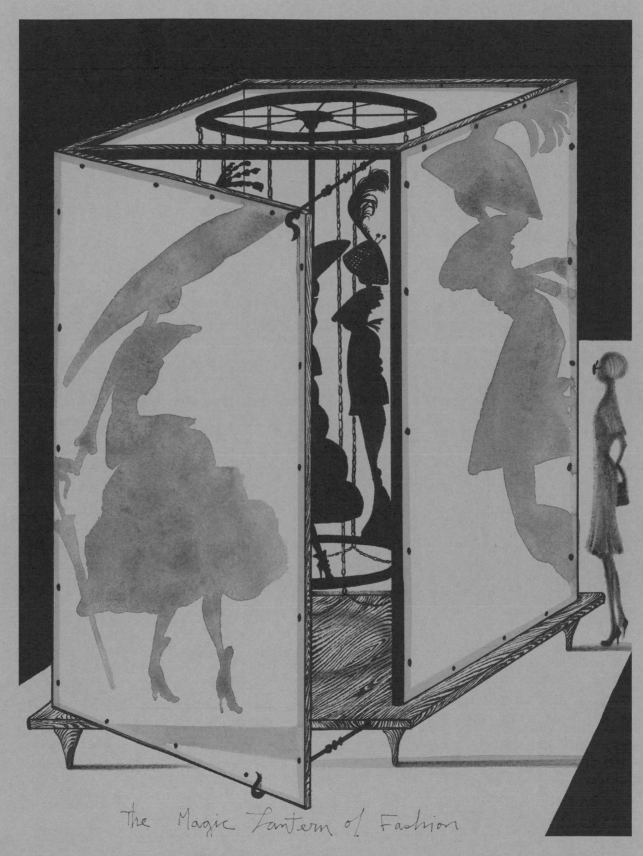

The Magic Lantern of Fashion

Remixing It: The Past in Pieces

Fashion is often shamelessly irreverent in its uses of the past. Styling into the present
often means literally combining the old and the new, the formal and the inappropriate,
the trivial and the elegant. >

 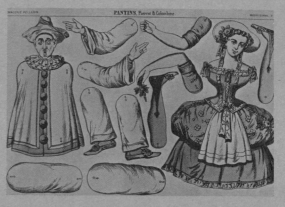

Jigsaw puzzle and lid, 19th century. **>p.94**

George Cruikshank, Changeable Heads (facial features could be switched about to make a number of permutations), 19th century.

Pierrot and Columbine cutouts (Pantins), late 19th century.

*Here history turns into a detective story, with the historical
trace as a clue. The figures of the collector, the ragpicker and
the detective wander through [Walter]Benjamin's landscape.
Thus the historian's method, like that of the designer, is akin
to that of the ragpicker who moves through the city
gathering scraps for recycling.*

Fashion at the Edge: 12

bearers of meaning and, as such, stretch simultaneously back to the past and forward into the future. Not just documents or records but fertile primary sources, they can generate new ideas and meanings and themselves carry discourse into the future, so that they take their place in a chain of meaning, or a relay of signifiers, rather than being an end product of linear history~~or a mythologised one~~.

~~In this context~~ Benjamin's concept of the /trace/, from his Arcades project, could be used in a new kind of cultural analysis, more fragmented and less coherent than the historian's, in which the fashion historian and the designer alike are scavengers, moving through cultural history like the figure of the ragpicker sifting rubbish in the nineteenth century city.[48] The historical fragment, or trace, can illuminate the present. Benjamin uses the term /trace/ to describe the mark left by the fossil (that is, the commodity) on the plush of bourgeois interiors or on the velvet linings of their cases.[49] Here history turns into detective story, with the historical trace as a clue.[50] The figures of the collector, the ragpicker and the detective wander through Benjamin's landscape. Thus the historian's method, like that of the designer, is akin to that of the ragpicker who moves through the city gathering scraps for recycling. Irving Wohlfarth argues that the ragpicker, as a collector of 'the refuse of history', is the *incognito* of the author: 'the historian as *chiffonier* unceremoniously transports these leftovers of the nineteenth-century across the threshold of the twentieth.'[51] The result is a series of *chiffons*, not fragments but a sort of death mask of its own conception. The rag-and-bone historian is a cousin of the Shakespearean grave digger, 'the grave digger of the bourgeois world'.[52] Indeed the

20

To make a collage look like a composition, to fit the disparate pieces together, the past has to be taken apart. Old themes are worn as new details. Eccentric outfits are created by exhibiting the contemporary garments with the historical garments as though they were a set of cards, though the set is infinite.

Happy Families playing cards, early 20th century.

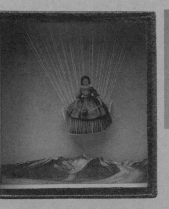

Joseph Cornell, *Tilly Losch,* about 1935. Mixed media.

The Physionotrace, early 1800s. Watercoloured lithographs and cardboard.

31

magazine poses of Leigh Bowery and Trojan from the mid-1980s creating something from ephemera in their self-representation, as when Trojan cut his ear and then rouged it with lipstick in a parody of Van Gogh. Out of these same groups emerged a form of urban ragpicker, the charity shop stylists whose work figured largely in the magazine *i-D*, and whose magpie aesthetic sought and found items of cultural detritus to recycle into new, cutting-edge, magazine imagery. This bricoleurs' aesthetic that characterised British clubs and sub-cultures in this period also provided a model of the design process for designers like Jean-Paul Gaultier in Paris and Westood and Galliano in London, and goes some way to explaining their own versions of cut-and-mix in the 1980s. For the metropolitan body that was on display in 1980s London was both informed and defined by the street, mediated by the new fashion magazines such as *Blitz, i-D,* with its 'straight-up' street fashion photographs, and *The Face.* In differing degrees these magazines reconfigured the cultural geography of the street through a 'reportage' style of fashion journalism that relied as much on coverage of street- and club-led innovation as on traditional fashion editorial coverage generated by the magazine itself. The power of these magazines' editors was to map fashionable identities onto British cities and then disseminate them across national boundaries through publication.

This scavenging aesthetic under-pinned much of the historicism of 1990s design that 'inaccurately' pillaged the past to produce a contemporary aesthetic. Rather than recreating one period, its historical borrowings were multi-layered. Like the 1990s *disc jockey* figure of the *DJ,* fashion designers sampled and mixed from a range of sources to create something new, rummaging through the historical wardrobe to produce clothes with a

37

This scavenging aesthetic under-pinned much of the historicism of 1990s design that 'inaccurately' pillaged the past to produce a contemporary aesthetic. Rather than recreating one period, its historical borrowings were multi-layered ... rummaging through the historical wardrobe to produce clothes with a strictly contemporary resonance. And in the same way that musical history lost its linearity when mixed by the DJ, who assumed a relationship with history and tinkered with it in the course of collecting, archiving and mixing tracks, so too did fashion and cultural history lose its linearity when 'remixed' by late twentieth-century designers folding one historical reference back on another.

Fashion at the Edge: 25

A New Distress

The worn out, the scrapped, the torn apart, burned or stained, are the material for the new distress: distress here meaning both the sign of trauma and the evidence of wear and tear. In repeating these bits and pieces a disturbing past is being referred to; something ruined is >

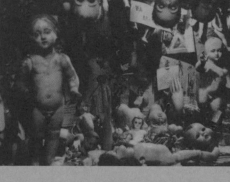

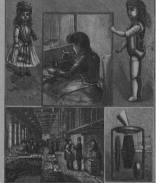

Shelley Fox, from *Doll Construction* series of photographs, 1999. Photographed in London's Museum of Childhood. **>p.102**

Herbert List, *Dolls Repair 1*, Neapel, 1961. **>p.115**

Hans Bellmer, *Untitled (self-portrait with a doll)*, 1934. Gelatin silver print.

Edison's phonographic doll. From *La Nature*, 1890.

A present haunted by the image of ruin in the future ... archaeological remains as a spatial metaphor for ruins, and in [Shelley] Fox's fashion narratives ruination becomes a way of excavating loss in the present through a series of melancholy returns to the past.

This concern with memory and the cultural artefact as a trace of the past has inflected fashion too, and for designers at the start of the twenty-first century, the map of the modern is not to be plotted on clean sheets of new white paper but painted over old landscapes whose surfaces are already traced with earlier palimpsests.

Fashion at the Edge: 56, 299

63

75

Vishniac's photographs documenting life in the Warsaw ghetto in the last months before its destruction and the annihilation of its occupants *in the Second World War*. These pictures of the daily life of its inhabitants are imbued with a tragic foreknowledge that creates what Roland Barthes called a 'vertigo of time defeated.'[19] Fox also listened to stories from her mother and grandmother to remind her that the 1930s and /40s were not *as* long ago as photographs made them seem. Such imagery brought the instability of the past into the present to demonstrate how fashion, too, can be 'a vertigo of time defeated'. The labyrinth brings together dizzyingly disconcerting moments of historical loss and trauma to recreate them on a fashion stage in 1990s London, as in Shelley Fox's solemn presentation of huge, peat-coloured woollen frills and scorched sequins.

Shelley Fox's work presented yet another form of haunting, a present haunted by the image of ruin in the future. Lynda Nead has argued that the urban modernity of nineteenth-century London was 'not only haunted by the ruins of its past, but also possessed by dystopic visions of its future | | | | ruin is the vision of the contradictory impulses of modernity'.[20] Nead describes archaeological remains as a spatial metaphor for ruins, and in Shelley Fox's fashion narratives ruination becomes a way of excavating loss in the present through a series of melancholy returns to the past. Fox based her earliest collections from 1996 on labour-intensive hand-felting, scarring and scorching her fabrics, either in a heat press or by using a blow torch on them, replicating abject and destroyed textiles to produce an aesthetic of melancholy. The sad patina of her shrunken woollens and wrecked textiles evoked a melancholy trace of the past through which the ghosts of industrial modernity could haunt the present moment of post-industrial

being recovered. We have a second look at the material of the past; what we are looking for is obscure, but for some reason the fragments are alluring. We find a use for the things we had discarded and are intrigued by what is beautiful about them.

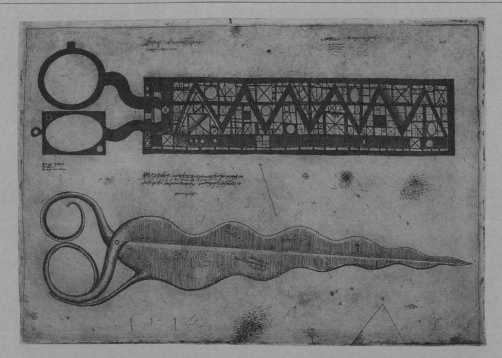

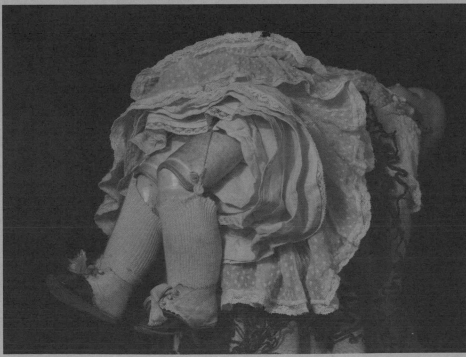

A Monument to Ideas

CAROLINE EVANS

1.

There is at the heart of *Malign Muses* a project to build ideas in space, sometimes through details of historical dress glimpsed at a distance, sometimes as a massive, constructivist set with moving parts that bring past and present fashion together in new, ever-changing constellations. Together, these add up to an exhibition that is a monument to ideas, and this piece explores how one might 'build' ideas in space, and what gets transformed on doing that. I have stolen my title from the fashion designer Hussein Chalayan, who described a series of moulded resin dresses he made as catwalk show pieces in the late 1990s as 'monuments to ideas', not because of their rigid structures but because he felt they were the purest, most uncompromising expression of ideas that elsewhere in the collections were explored in more diluted, and hence wearable, terms.

There is another sense, too, in which the exhibition is a monument to ideas: this response is written at a point in time that forms a natural pause, or break, in the evolution of the project. After two years of discussion and speculation, the exhibition has taken shape conceptually but it is not yet built, and it is quite possible that it will change again over the next few months. For now, however, the discussions are over and there is a lull before the detailed drawings and the construction begin. It seems a good time to look back on the conceptual framework, and forward, with anticipation, to its realisation in built space.

In the late 1990s I started to write a book on fashion that explored how the 'ghosts of modernity' haunted contemporary fashion. In order to think about fashion time, and how it operates in a non-linear way, I used a number of spatial metaphors, many of them drawn from Walter Benjamin's writing on fashion and on history, such as the labyrinth, the telescope, the diorama, and the 'tiger's leap'. At the end of 2001, after a research seminar in which we were both participants, Judith Clark suggested to me that she might curate something derived from these ideas because, I think, her imagination was caught by these metaphors and, having an architectural background, she immediately 'thought' them in space. Accordingly, I gave her an early draft of the manuscript to read. Over the next two years, we went on to have an extended conversation that we characterised as a dialogue between a writer and a curator, a dialogue that was to start with my book and end with her exhibition. It was recorded in notebooks, but this piece is not part of that record. Nor have I attempted here to sum up or describe the way in which I think Judith has crafted an exhibition from her own original insights into my material, something I could not possibly do justice to anyway. Instead, I have responded in my own way to her ideas. The piece is about a whole new set of ideas that were catalysed for me by our conversations, and this text is therefore perhaps best read as a parallel text to the exhibition.

*

2.

As we began to meet on a regular basis and talk about what the exhibition might be, I became aware of its singularity. From the start, Judith thought as much as an architect as a curator, scrambling these usually discrete roles. Whereas most curators start with a topic, then draw up an object list, and finally give it to a designer who makes the

layout intelligible, Judith thought spatially from a much earlier stage. Thus, in our conversations, her ideas for the space itself began to take on the shape of the exhibition's themes: labyrinths, phantasmagoria, fragments, ruins, historical views that would be occluded or blocked, merry-go-rounds and magic lantern shows. Sometimes it was not even clear to me what the objects would be, but the symbiotic process for bringing together both ideas and objects in the space was part of a continuing dialogue that characterised the very essence of the exhibition – for, in my mind at least, the installation itself was as much its subject matter as the objects that would fill it. Indeed, the idea of 'objects' or an 'object list' is somewhat challenged when a fashion illustrator (Ruben Toledo) is commissioned to make scaled-up magic lantern figures, or a jeweller (Naomi Filmer) to customise a mannequin, and when these have the same status in the exhibition as a dress by John Galliano, Alexander McQueen or Viktor & Rolf.

Because I was so intrigued by the idea of taking a metaphor and building it in space, I therefore became fascinated with other things that had been transformed, and started to look at a curious range of comparable examples and analogies. Few had any connection to fashion. My partner Calum introduced Judith and me to a book whose literary structure made it a labyrinth. Sven Lindqvist's *A History of Bombing* is laid out in numbered paragraphs from 1 to 399. The first 22 are 'entrances' into the book; each of these sends the reader to another numbered paragraph elsewhere in the book, and thus on to another, ad infinitum. As an alternative, this system can be ignored and the book read chronologically, but if the reader follows the labyrinthine path and makes it through all 22 gateways, they are simply returned again to the first, so the book is endless. The final line, 'and what is now is yet to come', serves both as Lindqvist's pessimistic conclusion to his historical thesis and as the *envoi* that will send the reader back to the beginning. That there was no exit from Lindqvist's book seemed an appropriate metaphor for the dark story of imperialism and destruction that it told. As the author explains on the first of his un-numbered pages:

> In order to move through time, you also have to move through the book, often forward, but sometimes backwards. Wherever you are in the text, events and thoughts from that same period surround you, but they belong to narratives other than the one you happen to be following. That's the intention. That way the text emerges as what it is – one of many possible paths through the chaos of history.

The idea of a book as a labyrinth became a curatorial talisman for a while. It articulated the metaphysical puzzle of turning time into space that is also described in Susan Sontag's introduction to Walter Benjamin's *One Way Street and Other Writings*, where she argues that Benjamin, in his writing on the city, spatialises time: in his essay 'A Berlin Chronicle' he recounts how he once drew a diagram of his life as a labyrinth, complete with dead ends and blind alleys.

<p style="text-align:center">*</p>

3. One day, many months into our discussions, I sent Judith a quotation from *Proust's Binoculars* by Roger Shattuck:

> Proust set about to make us *see time*… merely to remember something is meaningless unless the remembered image is combined with a moment in the present affording

a view of the same object or objects. Like our eyes, our memories must see double: these two images then converge in our minds into a single, heightened reality.

She replied:

> I love the idea of binoculars – 2, and always comparative, either confirming an image, strengthening it, putting it in context, or focus. You could have images almost projected onto others, or onto garments. Seeing time is such a great idea…

My understanding of Judith's aim for the exhibition is, partly, to take spatial metaphors for time (such as the labyrinth) and literally build them so that we might not only 'see time' but also occupy its physical space (the 'built time' of the giant cogs and wheels that are like over-scaled clock mechanisms). But although her constructions are intended to be concrete, they are not, in fact, literal, because in the process of coming into three dimensions these ideas may, in an alchemical way, become something else entirely.

Vision, optics and space: for me, these are the terrain of magical transformation. In our conversations I was often reminded of an illusion that can still be visited today: the Palais des Mirages in the waxworks museum in Paris, the Musée Grevin. Designed in 1906, it is, as described in the museum guide,

> A marvellous optical illusion based on the way parallel mirrors reflect the images before them to infinity. It was designed on the model of the *salle des illusions,* the highlight of the 1900 Exhibition… giving 45 different lighting effects… [by means of] a system of revolving mirrors which, by simple rotation, change the décor in an instant and transport the dazzled spectator from a Hindu temple to the heart of a forest and then to an Arabian palace. Infinitely varied lighting effects transform the spectacle of the décor at any given moment.

But mirrors, despite being powerful vehicles for visual magic and trickery, from the multiple-mirrored room in Orson Welles' *The Lady of Shanghai,* to the fluid mirror surfaces that mark the borders of dreamworld and reality in Cocteau's *Orphée,* are somehow also a distraction from the reality of building monuments to ideas.

It is the image and not its illusion or reflection that carries the power, the weight of things. The writer Italo Calvino made the connection between image and the imaginary when he described the faculty of *'thinking* in terms of images' in his lectures published posthumously as *Six Memos for the Next Millennium.* Growing up in Italy, as a child he had been given American comics whose English-language texts he could not understand. With recourse to nothing but the pictures, he thus grew up 'daydreaming *within* the pictures', and reading pictures without words became, for him, 'a schooling in fable-making, in stylisation, in the composition of the image'. Unsurprisingly, one of his early books was *Cosmicomics,* in which the image is turned back into text.

And when images or objects are freighted with meaning they exceed everyday narratives and become allegorical. Walter Benjamin in the *Arcades* project wrote of allegory as optical rather than linguistic: 'Images – my great, my primitive passion.' Allegory as optical – this is the key that unlocks the magic door into this kind of curating: the optical (Judith's construction, the edifice and the exhibits together) is a

gateway into a world of ideas. But how does the optical work as allegory? If allegory is a narrative that describes one subject under the guise of another, a spatial allegory must surely be one that masquerades as another kind of space, such as an exhibition that is really a labyrinth, a fairground entertainment, an optical illusion, or a constructivist set – or, in different parts, all of these.

Craig Owen wrote that allegory is consistently attached to the fragmentary, the imperfect and the incomplete. In Judith's plan the visitor moves through a terrain spotted with ruins and hybridised with rags. He or she comes up against unexpected distortions of scale, such as the gigantic magic lantern. There are dialectical juxtapositions: the revolving mannequins that fleetingly form new constellations before inexorably regrouping, recalling Benjamin's phrase 'the waxwork figure as mannequin of history'. Judith's revolving figures – muses of the 'then' and the 'now' – suggest that although fashion is a project that claims to be about renewal and novelty, its designers are nevertheless trammelled by the machinations of history. Yet, if you cannot get close to the historical pieces elsewhere in the exhibition, this is only because you cannot get close to history. The route through the space is 'now'; the past is everywhere around us, but imperfectly glimpsed and only partially experienced. Elsewhere the riff is reprised, but differently. The abandoned fairground or circus points to delusion and false history; a constructivist set posits the impossibility of the now through nostalgia for the past; a fragment of historical dress partially obscured suggests the labyrinthine processes of history. Here are dislocated images in which many narratives, histories and images are condensed – an 'optical whispering gallery' as Benjamin characterised the nineteenth-century panorama.

Two final quotations from Benjamin: 'Modernity has for its armature the allegorical mode of vision.' And: 'The pedagogic side of this undertaking: to train our image-making facility to look stereoscopically … into the depths of the shadow of history.' Stereoscopically … like the binoculars with which we see time.

*

4.

'To think is to speculate with images' wrote Giordano Bruno in his *Images* of 1591. In this, his final work on memory before he returned to Italy and the Inquisition, Bruno described 'a maze of memory rooms'. In his *Ash Wednesday Supper* of 1584, the 'Magus of Memory', as Frances Yates has called him, described an imaginary journey through the streets of London that was really an occult memory system in which he used London landmarks (the Strand, Charing Cross, the Thames, the French embassy, a house in Whitehall) to remember the themes of a cosmological and theological debate actually held in Oxford. Looking stereoscopically into the past myself, I found Bruno's elaborate mental constructions aligned, in my imagination, with Judith's spatial ideas for the exhibition.

I came upon Bruno's writing in Frances Yates's book on memory theatres. These were memory systems impressed on imaginary or real architecture, first used by the ancient Greeks. Yates argues that before the invention of printing, ways of remembering complex information had to be devised: what is commonly called 'mnemotechnics.' Thus an imagined building would be 'planted' with specific memories in each room and a mental walk round the rooms would recall the information 'stored' in each one. However, after the invention of printing, mnemotechnics became the arcane and specialist realm of neo-Platonists who devised memory theatres to express complex

theological systems. Very few were actually constructed, but the first, and most talked about by contemporaries, was actually built, probably in the 1530s, first in Venice and then in Paris for the King of France.

Guilio Camillo's semi-circular wooden theatre, based on the Vitruvian prototype, was a model of the human mind. Large enough to be entered by two people, it was full of images and little boxes, possibly with texts in them, arranged in various orders and grades. No audience sat in the seats; instead, the spectator stood on the stage and looked out at the images and ideas embedded in the theatre's structure that rose in seven concentric steps, divided by seven gangways, representing the seven Pillars of Wisdom, each culminating in an imaginary gateway decorated with images. These were Camillo's memory places, stocked with images. The theatre may have been intended as a representation of the universe, a 'Memory Theatre of the World', of which the human mind is the mere microcosm. But it no longer exists, and Camillo never wrote the book he promised that would have contained the detailed designs; what information there is about the theatre is frustratingly scant and his theatre thus acquires some of the mystique of a lost object or domain. There is a diagram that reconstructs it, based on contemporary texts, in Yates's book.

Thinking about memory theatres led me to other sixteenth- and seventeenth-century theatres, built ones, whose polyvalent spaces often seemed to masquerade as something they were not: could Renaissance and Baroque theatres be especially suited to function as allegorical images, or as stereoscopic ones that could be brought into a contemporary line of vision and aligned with a modern fashion exhibition?

Andrea Palladio's Teatro Olimpico in Vicenza (1580) was modified after his death by the architect Vicenzo Scamozzi (1585) to incorporate a fixed 'set' of receding streets that became a permanent feature of the theatre. The stage is thus a permanent ideal city with a false perspective, and the building is, therefore, not only a theatre but also a model of the world, with the city as its microcosm. The conceit is reversed in the nearby Teatro 'All'antica', designed by Scamozzi himself in 1588 for the centre of the rationally planned town of Sabbioneta near Mantua (1556–91). Scamozzi's theatre thus forms a neat counterpoint to his earlier modification of Palladio's – a theatre in the heart of an ideal town, as opposed to an ideal town at the heart of a theatre.

Thirty years later, in nearby Parma, there was a theatre built inside a royal palace. The Teatro Farnese, on the first floor of the Palazzo della Pilotta, was designed by the architect Aleotti (better known as L'Argenta) to celebrate Cosimo de Medici's visit to Parma in 1618. A unique structure, it had moveable scenery, machinery that could lift performers in the air, and a flooding system that converted the stage for nautical battles. It opened in 1628 but was used only nine times over the next 104 years, before it was left to fall into decay. I heard about this theatre in casual conversation with someone who had just returned from Parma, but the account was as Baroque as the building, or perhaps I transformed it as I listened. It became a sham theatre, a life-size architectural model built in paper-thin cherry wood, with only a couple of seats substantial enough to be sat in. How this account came about I don't know, but the impossible description invoked the same mystique as the descriptions of Camillo's (indubitably real, but lost) memory theatre, and the idea of a theatre that is really an architectural model of another kind of space also recalls Palladio's Teatro Olimpico.

The final architectural 'stage' I had in mind was the design by John Nash for

London's Regent Street of 1818–25, running from the Mall to Regent's Park. Now largely demolished, its plan remains visible in the curve of the street itself as it runs north from Piccadilly Circus, and there are remaining fragments at the north end of the original scheme, such as All Souls Church, Langham Place. Built as a promenading ground for fashionable display and to house luxury shops, the street was a stage set for the display of fashionable identities in the early nineteenth century, and although the buildings are gone, its theatrical sweep remains, a palimpsest of Nash's *mis-en-scène.*

<div align="center">*</div>

An exhibition designer, too, stages things. But the stage also transforms, and in *Malign Muses* the stage itself is the exhibit, the object *of* display as much as the vehicle *for* display. This exhibition is, like the Teatro Farnese in Parma, a complex and dramatic architectural structure built inside a much larger one. Curatorially, it resembles a model (Palladio's Teatro Olimpico), a memory theatre (Camillo's), an optical illusion (the Palais des Mirages), a labyrinth (Lindqvist's book), and a 'maze of memory rooms' (Bruno's architectonic memories in *Images*). Who knows what else it may become, once built? Like a stage, it waits to be animated, but not by the usual troupe of player actors. Rather, it will be peopled by the visitors to a twenty-first century fashion exhibition, stepping into the shoes of their ghostly predecessors: the intellectually curious visitors to a Renaissance memory theatre, the crowds at the *salle des illusions* in the 1900 Paris exhibition, or the fashionable promenaders in Nash's regency London.

I envisage the visitors standing in the midst of the display itself, as the visitors to the Palais des Mirages in Paris stand, surrounded by the rotating mirrors of the installation, mesmerised by its visual trickery. Or I see them like the paired visitors to Camillo's theatre in the sixteenth-century city, gazing from centre stage at the exhibition's spatial structures and the objects they house. Like a memory theatre, all the 'sets' and set pieces of *Malign Muses* are gateways into the world of ideas, their objects laden with meaning. In *Malign Muses*, as in the microcosm of the world built in to the stage at the centre of Palladio's Teatro Olimpico, I imagine the streets and doorways of the set will take the visitor beyond the physical space of the stage, into the expanded world of images and ideas.

<div align="center">*</div>

References
Benjamin, Walter, *The Arcades Project,* trans. Howard Eland and Kevin McLauchlin, Belknap Press of Harvard University Press, Cambridge Mass. & London, 1999, pp334, 533, 531, 336
-------- , *One Way Street and Other Writings,* with an introduction by Susan Sontag, trans. Edmund Jephcott and Kingsley Shorter, Verso, London, 1985, pp318–9
Bruno, Giordano: see Yates
Calvino, Italo, *Cosmicomics,* trans. William Feaver, Abacus, London, 1982
Calvino, Italo, *Six Memos for the Next Millennium,* trans. Patrick Creagh, Jonathan Cape, London, 1992, pp92–4
Lindqvist, Sven, *A History of Bombing,* trans. Linda Haverty Rugg, Granta Books, London, 2001
Owen, Craig, 'The Allegorical Impulse: Towards a Theory of Postmodernism' in *Beyond Recognition: Representation, Power and Culture,* ed. Scott Bryson et al, University of California Press, 1992, pp52–69
Shattuck, Roger, *Proust's Binoculars,* Princeton University Press, 1983, pp46–7
Yates, Frances A., *The Art of Memory,* Pimlico, London, 1992, pp141, 173, 284, 289, 297, 371

5.

Dress

*

*I imagined a labyrinth of labyrinths, a
twisting, turning, ever-widening labyrinth that contained both
past and future and somehow implied the stars ... I saw it – The
Garden of the Forking Paths was the chaotic novel; the phrase
'several futures (not all)' suggested to me the image of a fork in
time, rather than in space ... In all fictions, each time a man
meets diverse alternatives, he chooses one and eliminates the
others; in the work of Ts'ui Pen, the character chooses –
simultaneously – all of them ... The Garden of the Forking Paths
is an incomplete, but not false, image of the universe as
conceived by Ts'ui Pen. Unlike Newton and Schopenhauer, your
ancestor did not believe in a uniform and absolute time; he
believed in an infinite series of times, a growing dizzying web of
divergent, convergent and parallel times. That fabric of times
that approach one another, fork, are snipped off, or are simply
unknown for centuries, contains all possibilities ...*

'The Garden of the Forking Paths' in J.L. Borges *Ficciones*, Alianza Editorial, S.A., 1999.

(Left to right)
Victorian photocards by C.V.Bark, W.E.Wright, T.Monk,
J.T.Jerrard, T.J.Bonne, T.Coleman, 1890s.

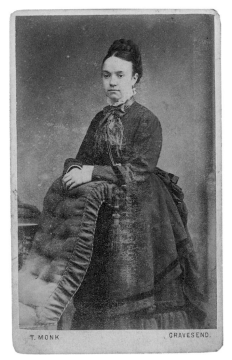

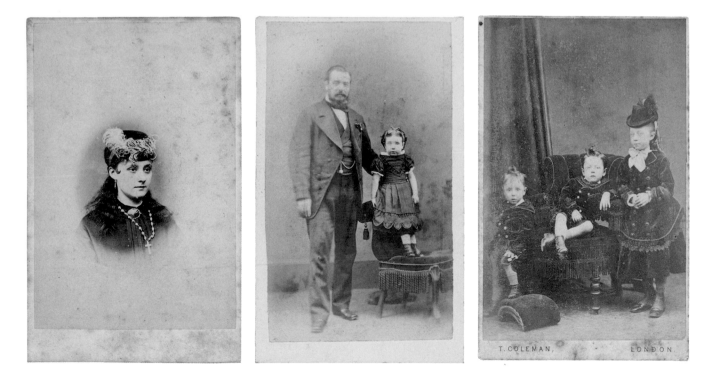

(Below)
Pepper's Ghost
Veronique Branquinho *Blouse and skirt, Spring-Summer 1999.*
Collection MoMu, T98/59 – T98/60
Baptism robe decorated with torchon lace and bobbin lace, 1900-50.
Collection MoMu, MFA65.42.53

(Right)
Veronique Branquinho *Spring-Summer 1999.*

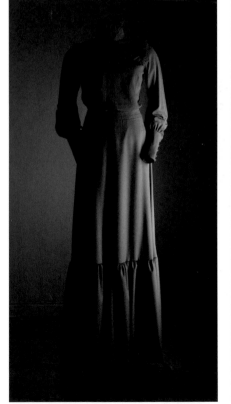
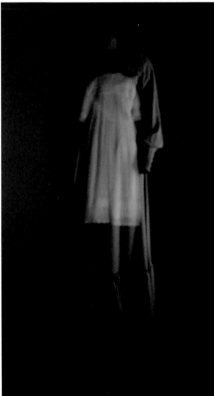

(Anti-clockwise from top)

Child's dress decorated with machine lace, 1900-20.
Collection MoMu, AF180AB

Baptism robe decorated with white on white embroidery, 1850-75.
Collection MoMu, T3137

Flounced child's dress, 1850-75.
Collection MoMu, MVT370

Fragment of a baptism robe decorated with imitation Valenciennes lace and white on white embroidery, 1800-1940.
Collection MoMu, T3140

Baptism robe decorated with torchon lace and bobbin lace, 1900-50.
Collection MoMu, MFA65.42.53

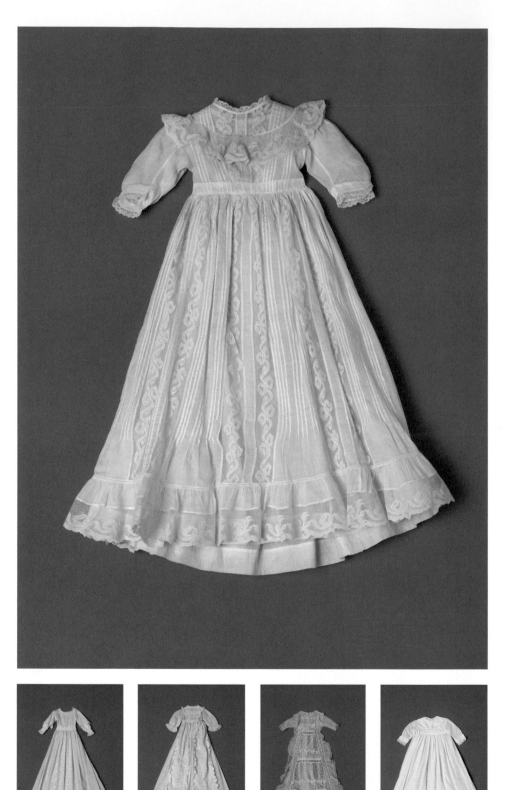

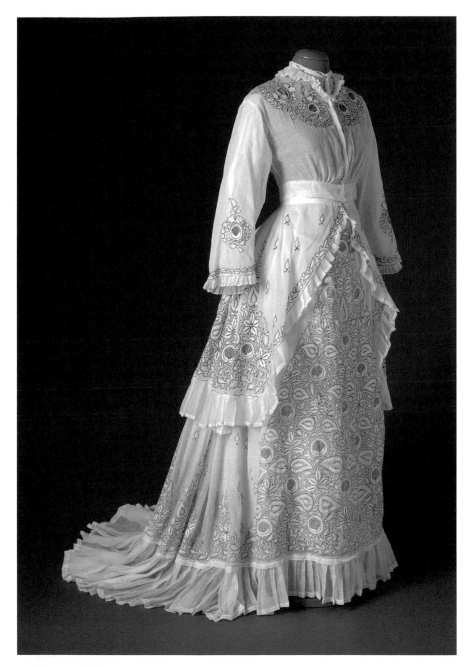

(Anti-clockwise from top)

Summer dress in white muslin, with Indian chain stitch embroidery, 1870-80, India.
(front and back views)
Collection MoMu, T94/245ABC

Wedding dress in off-white silk, 1900-10.
Collection MoMu, S64/106AB

Empire style dress in white embroidered cotton, 1800-10.
Collection MoMu, S76/1ABC

Empire style dress with embroidered flowers, 1800-10.
Collection MoMu, T80/202

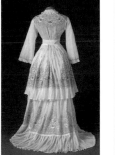
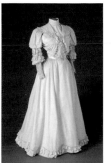
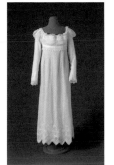
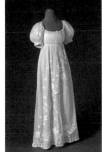

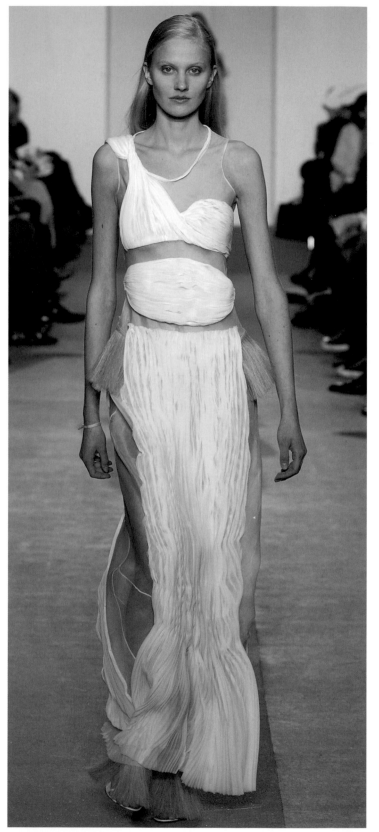

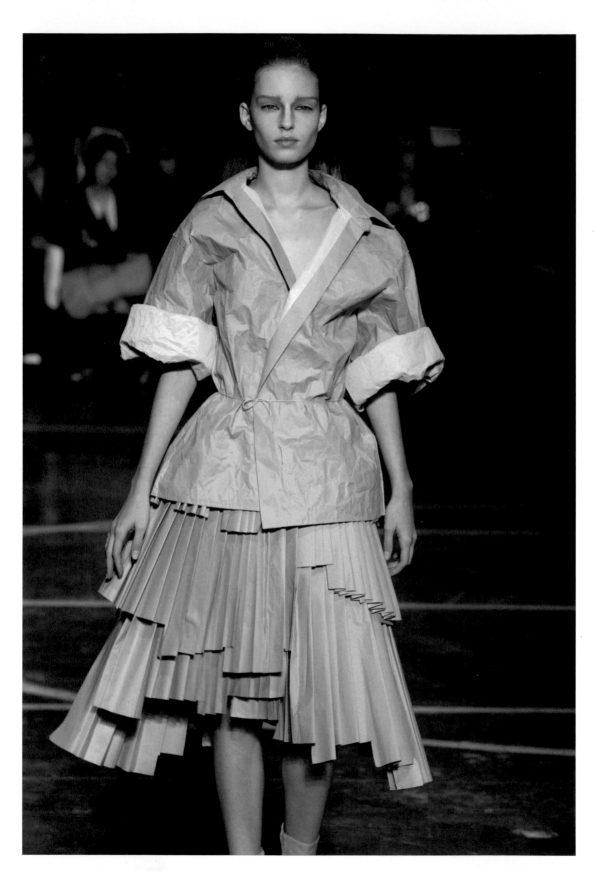

(Left)
A.F. Vandevorst
Spring-Summer 2004.

(Right)
Yohji Yamamoto
Autumn-Winter 1991-92.

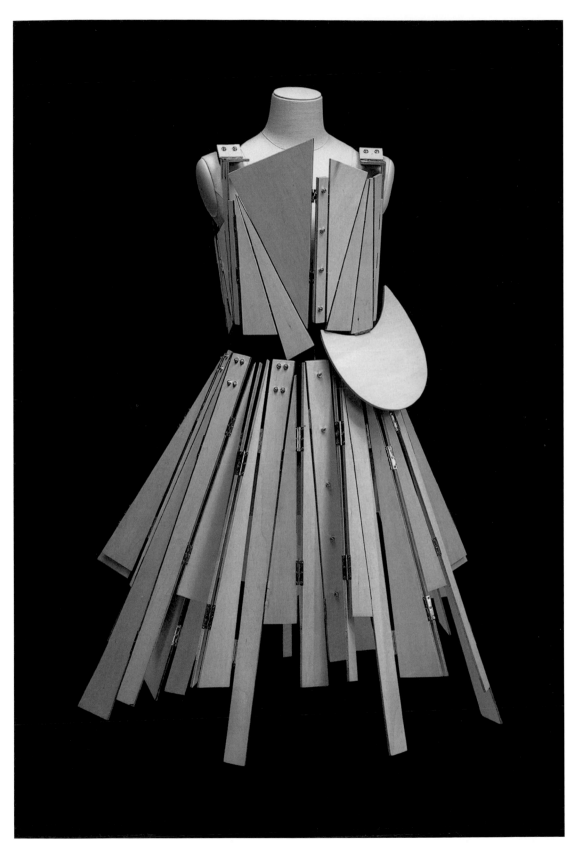

(Below left and right)
Rochas by Olivier Theyskens *Autumn-Winter 2003-04.*

(Far right)
Christian Dior *Black silk tulle and bones cream silk with bugle beads and satin ribbons (detail). Designed by Yves Saint Laurent for the house of Dior, Spring-Summer 1959.*
V&A, T.125-1974

(Below)
Comme des Garçons *Autumn-Winter 2004-05.*

(Right)
Blouse sleeve (detail). Black damask with chrysanthemum
motive and embroidered flowers, 1890-1910.
Collection MoMu, MFA63.50.1

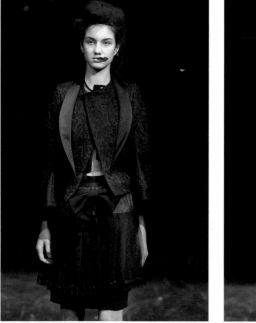

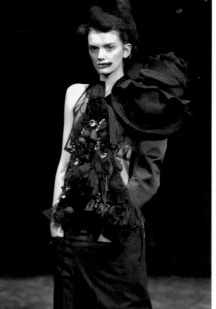

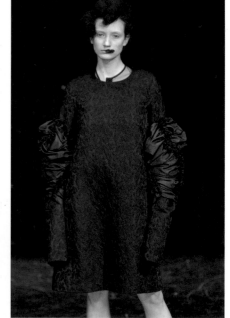

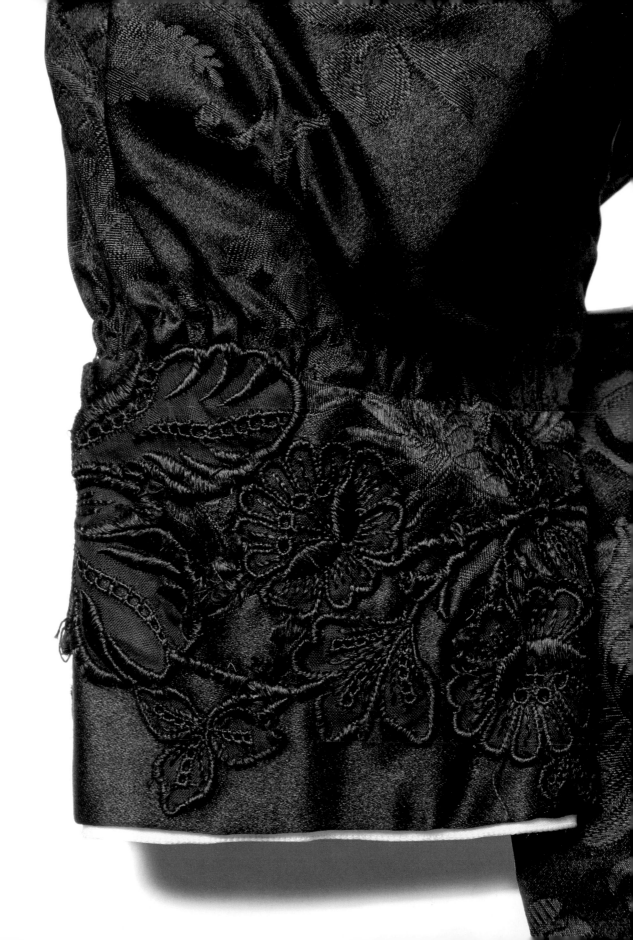

(Left and below)
Pierre Cardin *Mini-dress, 1968.*
V&A, T. 260-1983
(Right)
Hussein Chalayan *Remote Control dress, Spring-Summer 2000.*

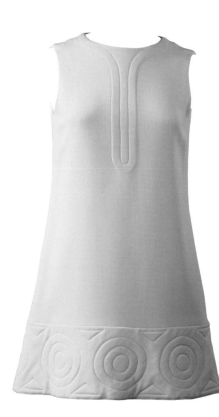

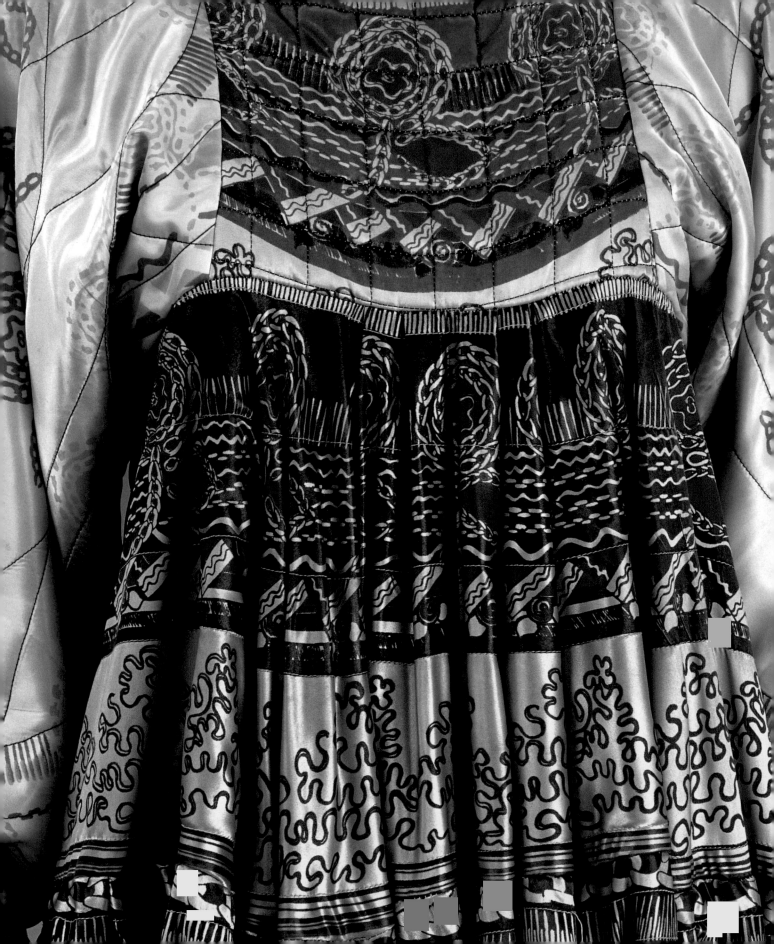

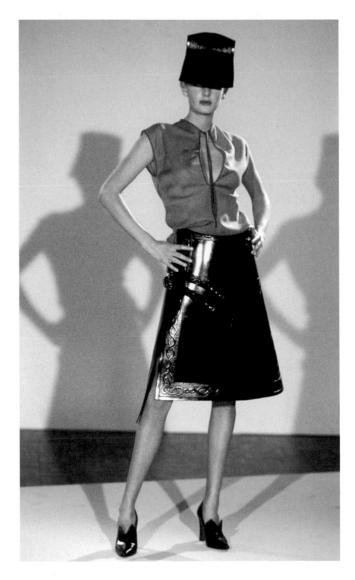

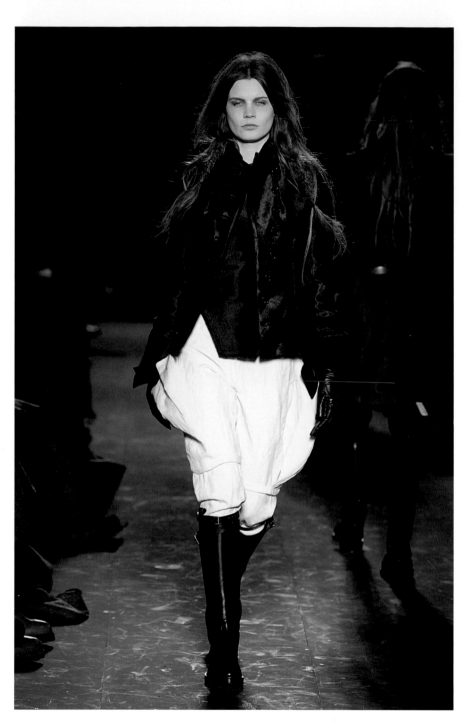

Ann Demeulemeester *Autumn-Winter 2004-05.*

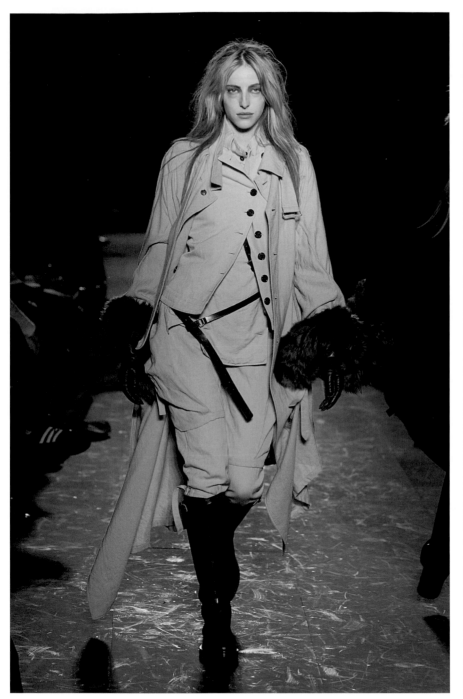

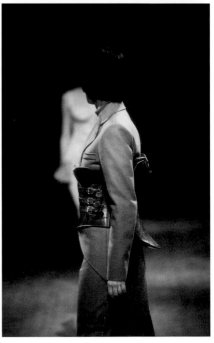

(Above)
Ann Demeulemeester *Autumn-Winter 2004-05*.

(Above right)
A.F. Vandevorst *Leather corset with saddle, khaki felt
frock coat and pants, Autumn-Winter 1998-99*.

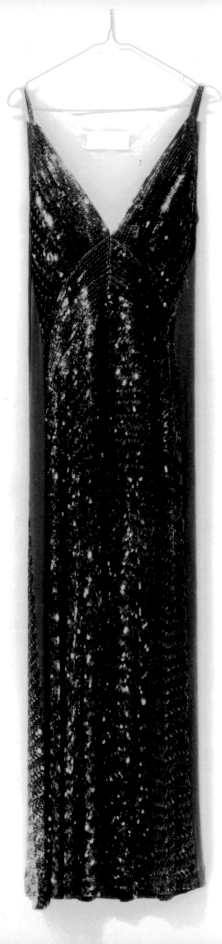

(Left)
Maison Martin Margiela *Viscose evening dress
with a print of a long, sequinned evening dress,
Spring-Summer 1996.*

(Right)
Dries Van Noten *Sequinned waistcoat (detail),
Autumn-Winter 2003-04.*

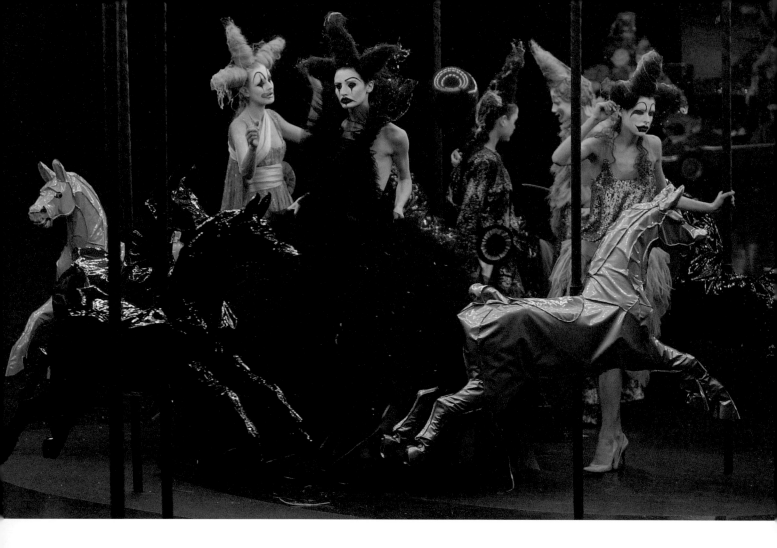

(Above)
Alexander McQueen *Autumn-Winter 2001-02.*

(Above right)
Elsa Schiaparelli *Circus jacket (detail), silk twill with cast metal buttons, 1937.*
V&A, T.395-1974

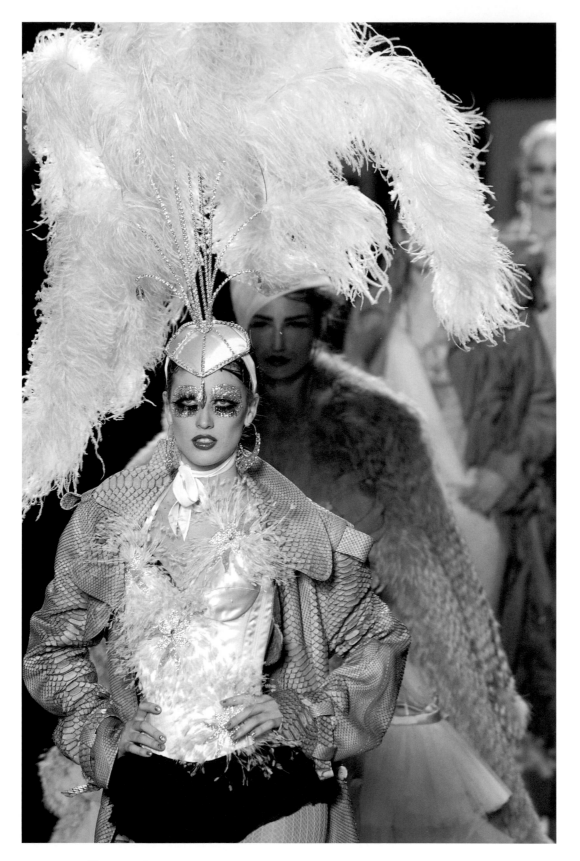

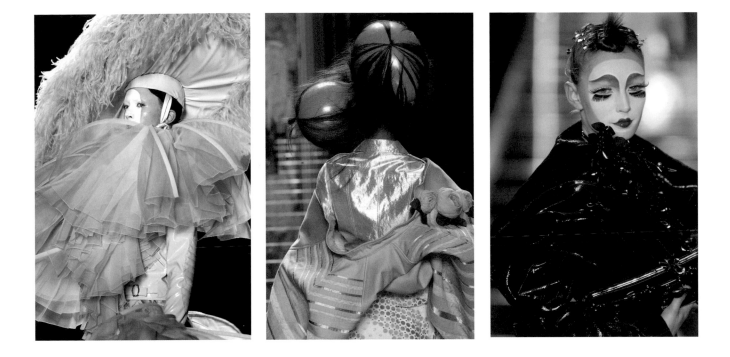

(Left, above and above far right)
Christian Dior *Spring-Summer 2003.*

(Above middle)
John Galliano *Spring-Summer 2003.*

(Below left)
Mary Quant *Black and white check, 1956-57.*
V&A, T.102-1976

(Below right)
Mary Quant *White crêpe and black braid, 1964.*
V&A, T.108-1976

(Right and far right)
Bernard Willhelm *Autumn-Winter 2002-03.*

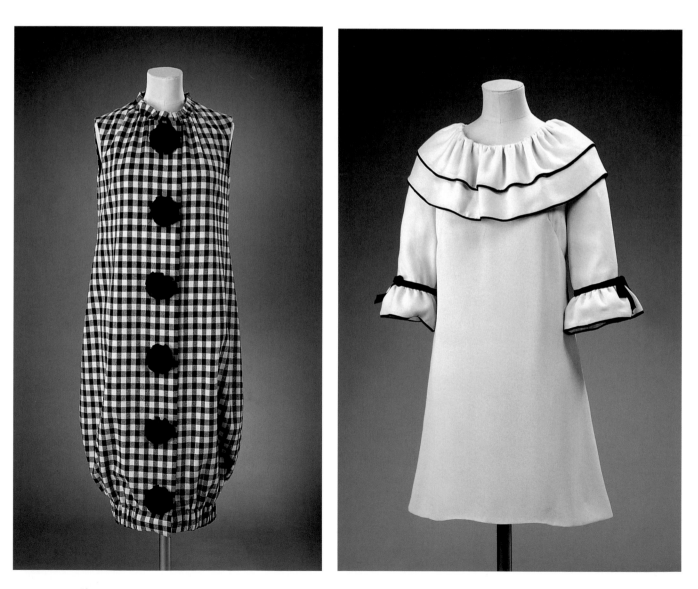

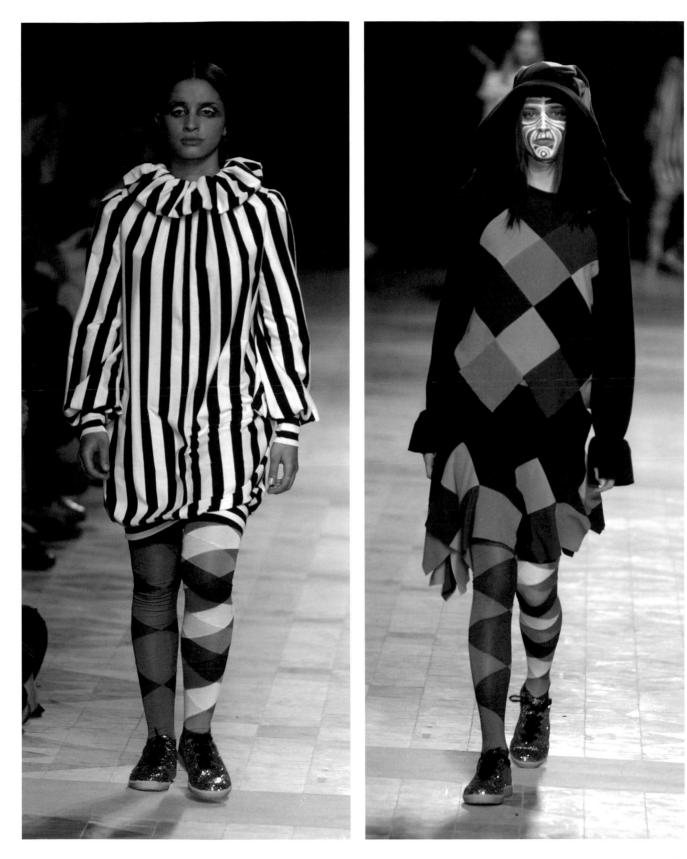

Elsa Schiaparelli *Harlequin Ensemble, silk satin jacket and*
trousers with silk organza ruffs and wristlets, 1951.
V&A, T.396-1974

Lucien Clergue *Saltimbanques, Arles, 1954.*

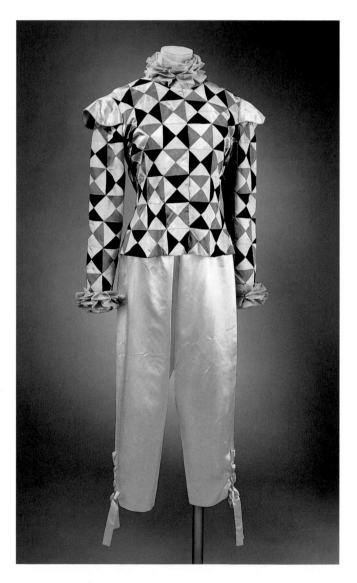

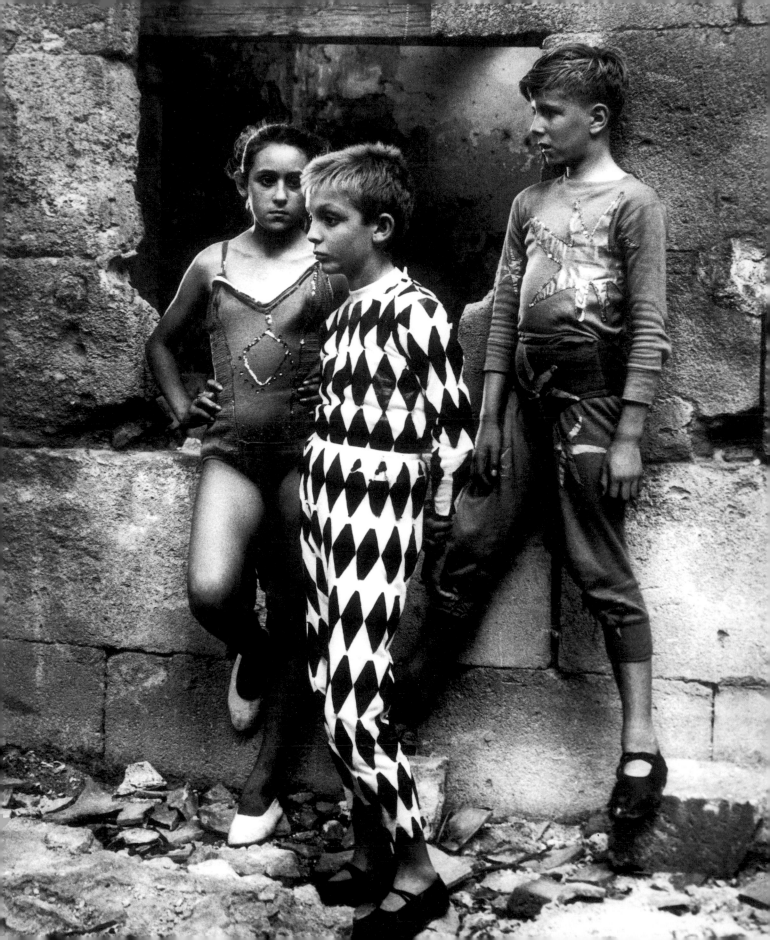

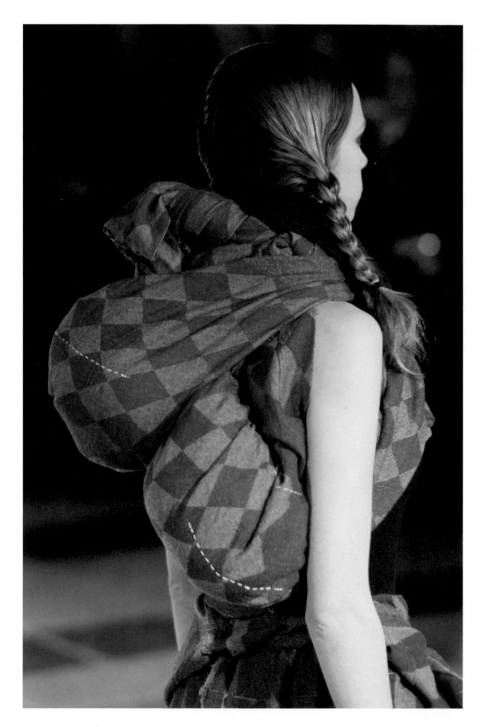

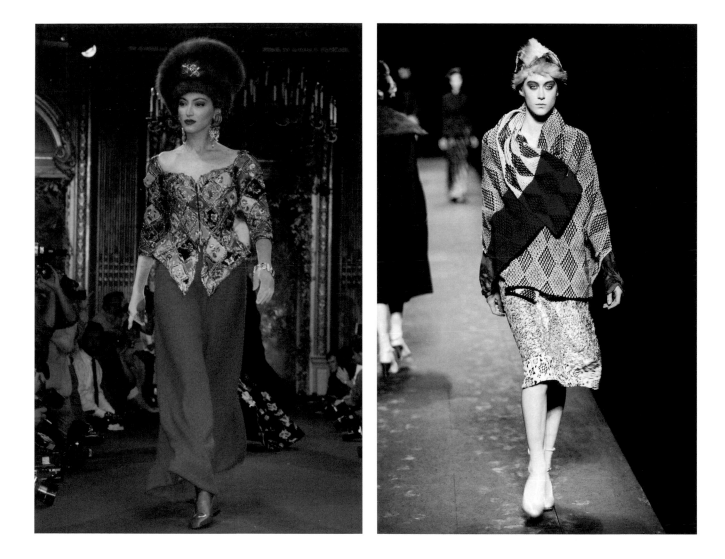

(Far left)
Comme des Garçons *Autumn-Winter 2003-04*.

(Above left)
Christian Lacroix *Haute Couture Autumn-Winter 1988-89*.

(Above right)
Dries Van Noten *Scarf and skirt, Autumn-Winter 2003-04*.

Dries Van Noten *Autumn-Winter 2000-01.*

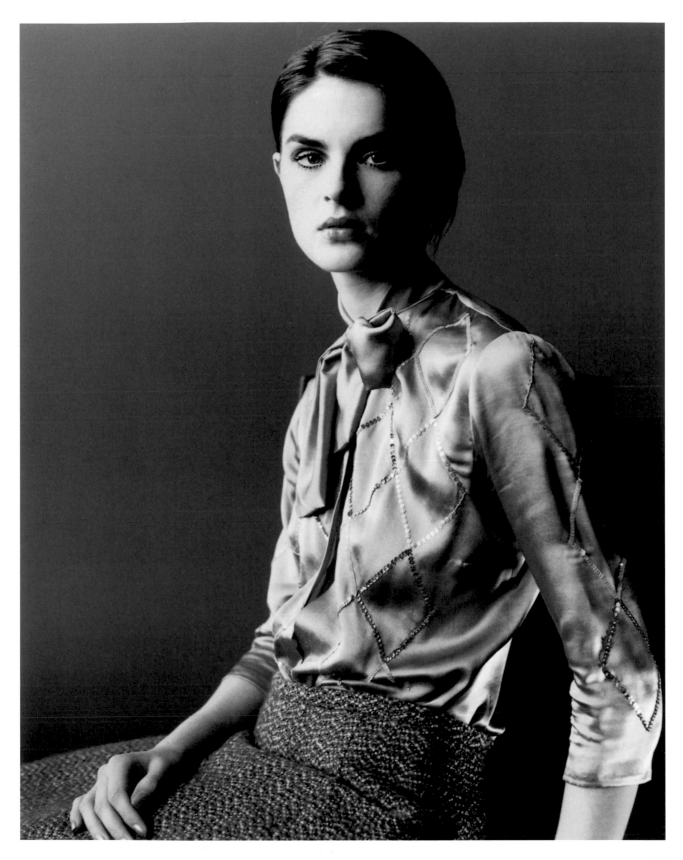

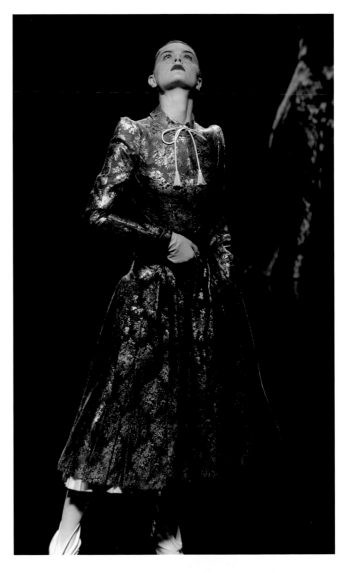

Elsa Schiaparelli *The skeleton dress, stylised version of the human skeleton (detail), 1938.*
V&A, T.394-1974

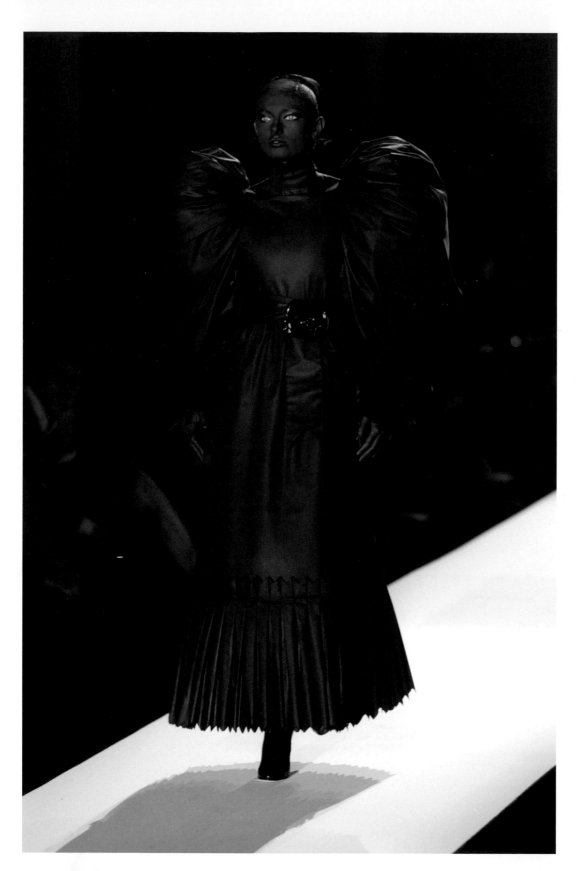

(Left)
Viktor & Rolf *Autumn-Winter 2001-02.*

(Below left)
Jean Dessès *Voided velvet in check pattern with velvet brassiere
and zip fastening, 1948.*
V&A, T.113-1974

(Below right)
Christian Dior *Black silk faille, boned with tulle petticoat, 1955.*
V&A, T.118-1974

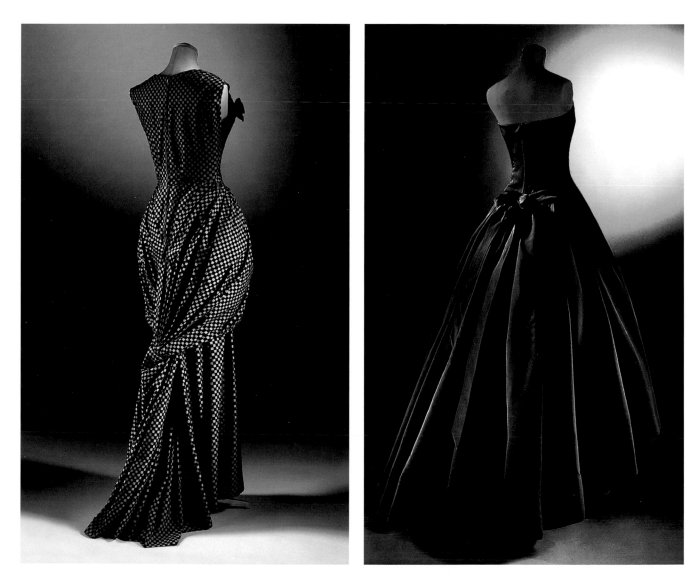

(Right)
Rochas by Olivier Theyskens *Autumn-Winter 2003-04.*

(Below)
Dries Van Noten *Spring-Summer 2000.*

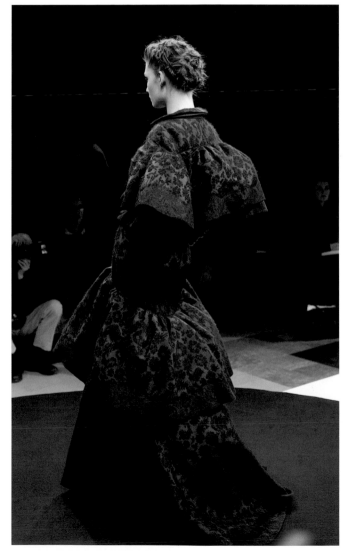
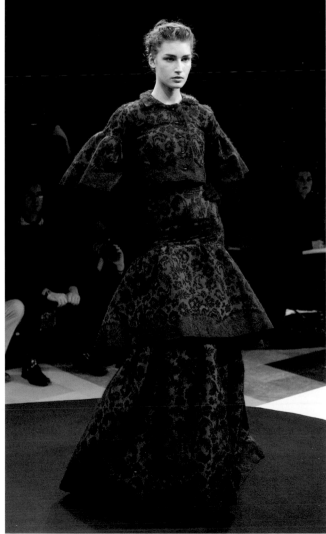

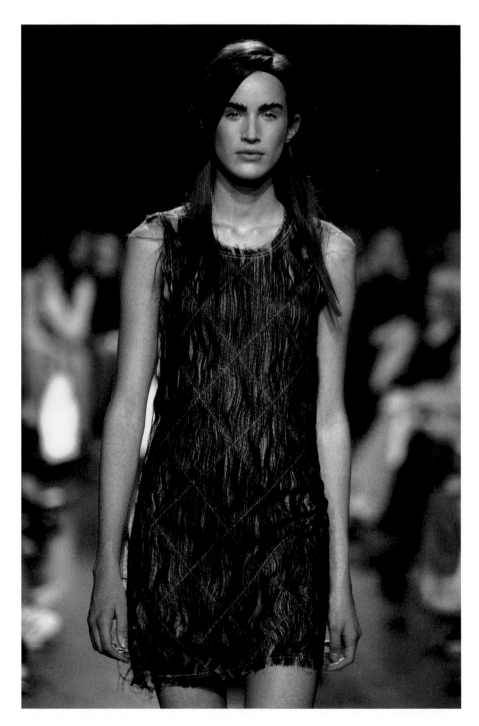

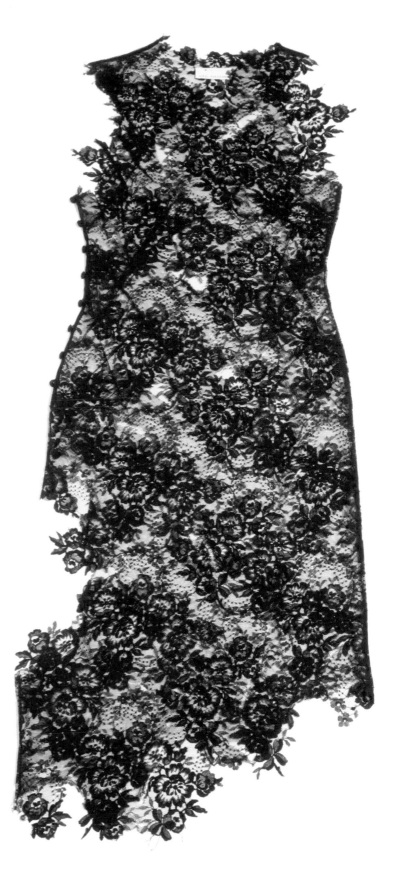

•R.Q.• (3)

$$\sqrt{0} + 3$$

JOHN GALLIANO

•R.Q.• (4)

$$\sqrt{\dfrac{\square}{0}}^2$$

JOHN GALLIANO

• Ai quadrati! Niente di più quadrato dei tavolini da bistrot con tovaglie naturalmente quadrettate, preferibilmente bianche e rosse... Bistrot look per le ragazze-tovaglia di Moschino, che usa anche i carreaux bianchi e neri dei pantaloni da chef costellati di fiorellini rossi. La radice quadrata collega molte collezioni: riquadri di catene nella collezione "Black hole" di Viktor & Rolf, i plaids gotici, in colori... acidi di Jean-Charles de Castelbajac, con un inedito clan Dracula. Il quadrato ha enfasi e origini diverse: i quadretti de cravatteria di Marni, il classico tessuto da kilt, con

dominante rossa, di Dolce & Gabbana, da abbinare rigorosamente a lunghe file di perle; i labirinti con matrice quadrata di Versus, con colori segnaletici. E poi ci sono straordinarie geometrie di ceppo artigianale, come un colorato mantello a crochet di John Galliano. Infine, per seguire un altro suggestivo filone storico, i complessi motivi ispirati ai quilts degli Amish americani nella collezione di Missoni. Perfetti esempi di patchwork art, soprattutto nella girandole caleidoscopiche: preziosi accenti di moderno knit-wear. Naturalmente con radice quadrata! Foto di Bardo Fabiani

• RADICE QUADRATA •

D.P.

$$\sqrt{0} + \square^2$$

DOLCE & GABBANA

di Anna Piaggi

•R.Q.• (2)

$$\sqrt{\square}$$

JEAN-CHARLES DE CASTELBAJAC

• Un'allegra... square dance di checks, carreaux, tartans, scozzesi basculati, plaids rielaborati, pied-de-coq e damiers, nelle nuove collezioni autunno-inverno 2001-2002. Ma della clan-culture, con gli aristocratici imprints Mackintosh, Macdonald, Stewart o dei Royal Tartans di Balmoral, emergono soprattutto fantasiose e coloratissime radici, con patterns quadrati e riquadrati doppi, tripli, multipli, come in un gioco matematico... Trattati con ironico twist, con moderne deformazioni, con abbinamenti improvisati e senza nessuna ufficialità: il reggiseno sotto l'impermeabile (a disegni

Ogilvie...). I fiori con il madras, come bordo, come fodera, e persino il Principe di Galles acquista un nuovo sense of humour con accessori coordinati, fiori quadrettati, o come mad mix con altri tessuti "classici" come fa Comme des Garçons. La "quadratura" generale ha anche un motivo-simbolo nella ricomparsa della geometrica e decorativa fibbia, un dettaglio storico dell'abbigliamento soprattutto maschile dal XVI al XVIII secolo. • Tra le fibbie attuali, la più simbolica quella di Dolce & Gabbana, con accenti Sixties, tipico anche di un gusto "medioevale", che è nell'aria...

94 * DRESS *Remixing It*

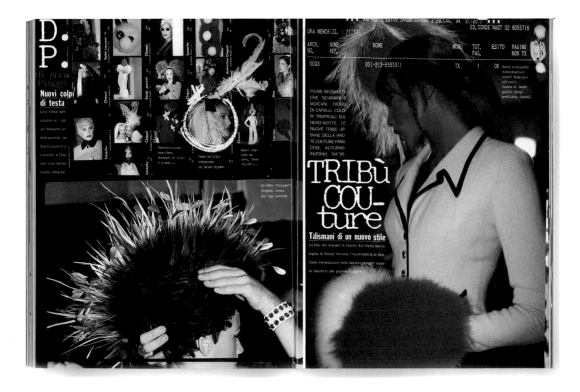

(Previous spread, p.94)
Anna Piaggi *Doppie Pagine di A.P.* spread from Italian Vogue, August 2001.

(Previous spread, p.95 top)
Anna Piaggi *Doppie Pagine di A.P.* spread from Italian Vogue, October 1992.

(Previous spread, p.95 bottom)
Anna Piaggi *Doppie Pagine di A.P.* spread from Italian Vogue, September 1994.

(Below)
Simon Thorogood *Fragment/a Collection 2004.*

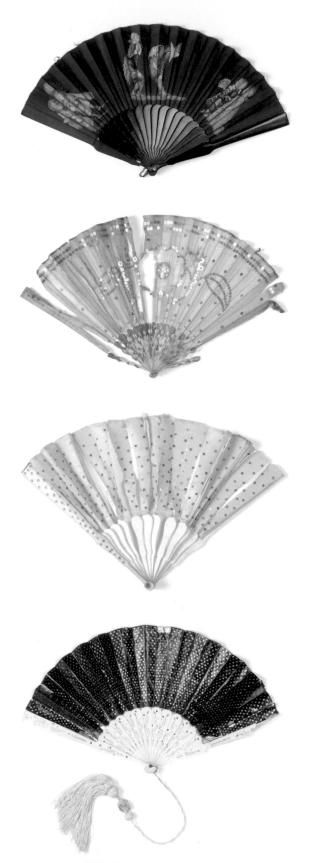

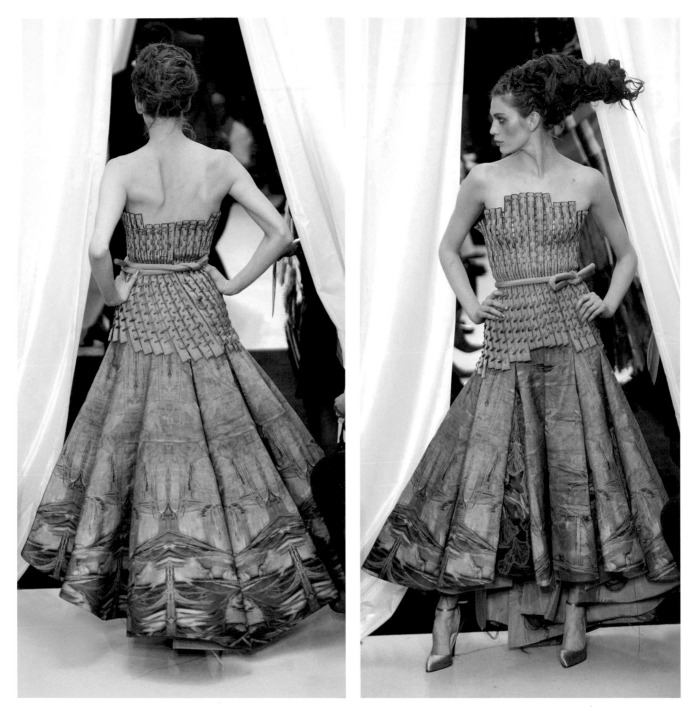

(Left from top to bottom)

Fan *1890-1910*. Collection MoMu, T92/248

Fan *1800-40*. Collection MoMu, TVT21

Fan *1800-40*. Collection MoMu, TVT20

Fan *1800-50*. Collection MoMu, T4614

(Above)

Jean-Paul Gaultier *Haute Couture Spring-Summer 2004*.

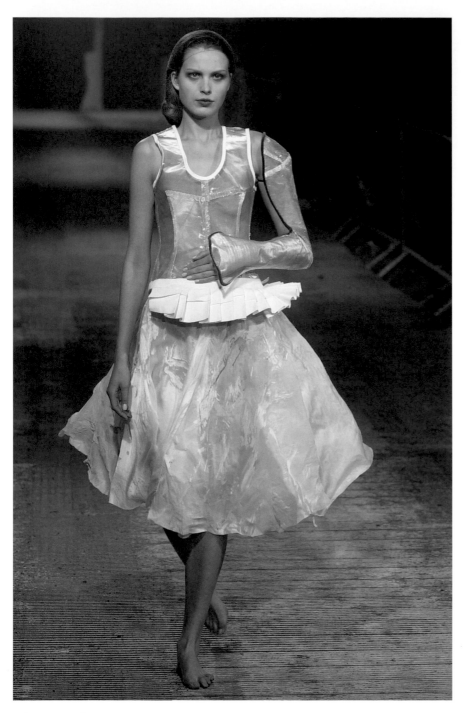

Robert Cary-Williams *Autumn-Winter 2000-01.*

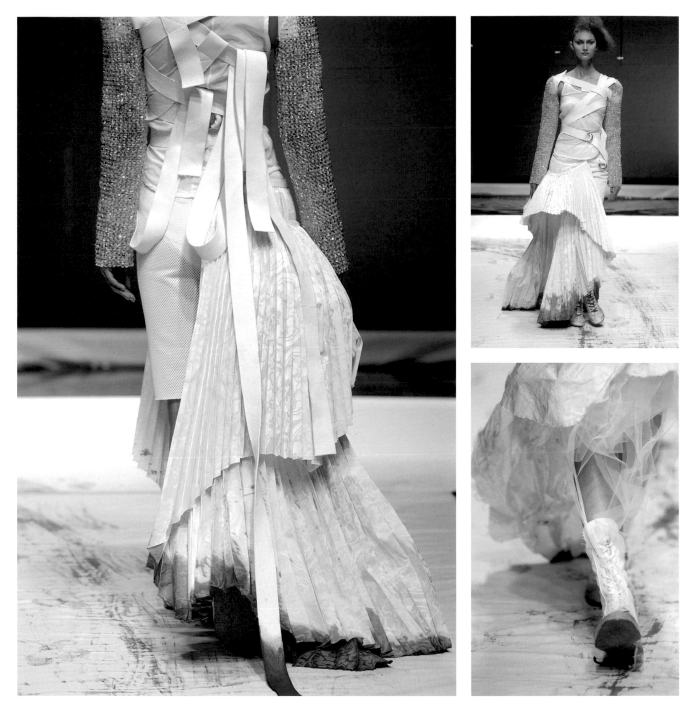

Hamish Morrow *Spring-Summer 2002.*

(Below left)
Shelley Fox *Number 9, Autumn-Winter 2000-01.*

(Below middle and right)
Alexander McQueen *Autumn-Winter 2000-01.*

(Right)
A.F. Vandevorst *Spring-Summer 2004.*

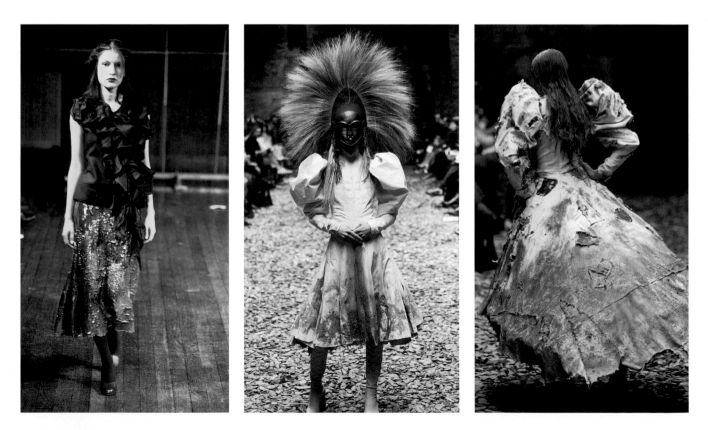

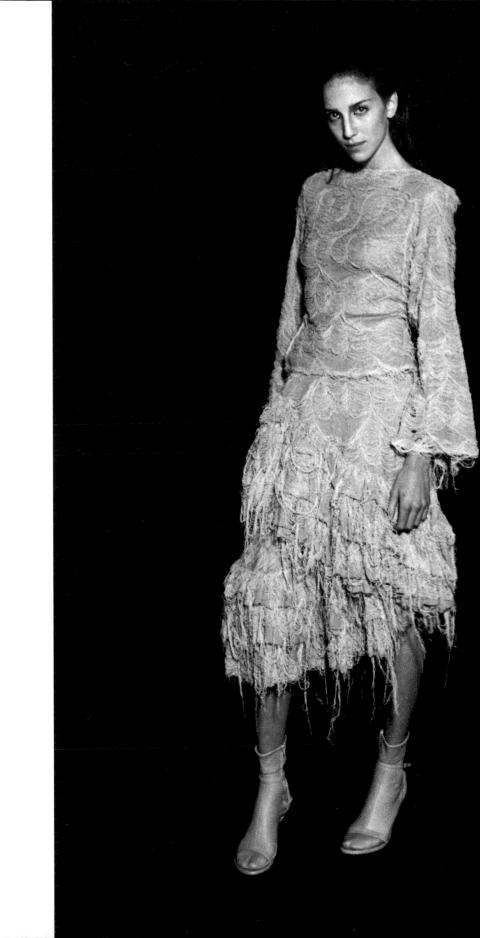

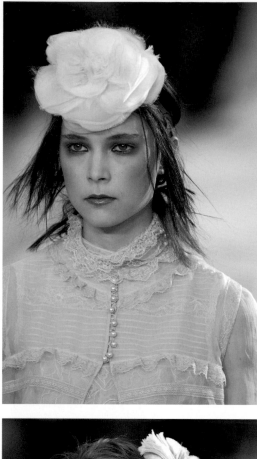

(Left and below left)
Chanel Haute Couture by Karl Lagerfeld *Spring-Summer 2002.*

(Right)
Dirk Van Saene *Dress with floral motive (detail), Spring-Summer 2004.*
Collection MoMu, T04/17

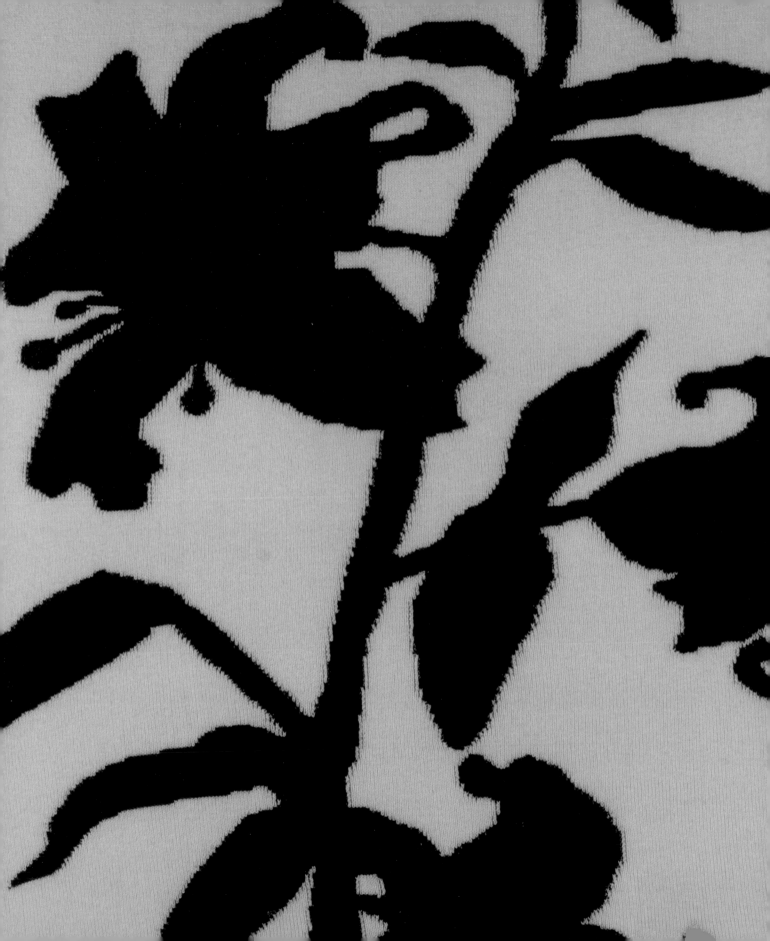

(Above)
Dress with floral motive (detail), 1955-60.
Collection MoMu, T88/61

(Right)
Gown, silk polonaise (detail), late 1770s.
V&A, T.30-1910

(Far right)
Dress coat and waistcoat, silk (detail), 1745.
V&A, T.147-1964 and V&A, T.148-1964

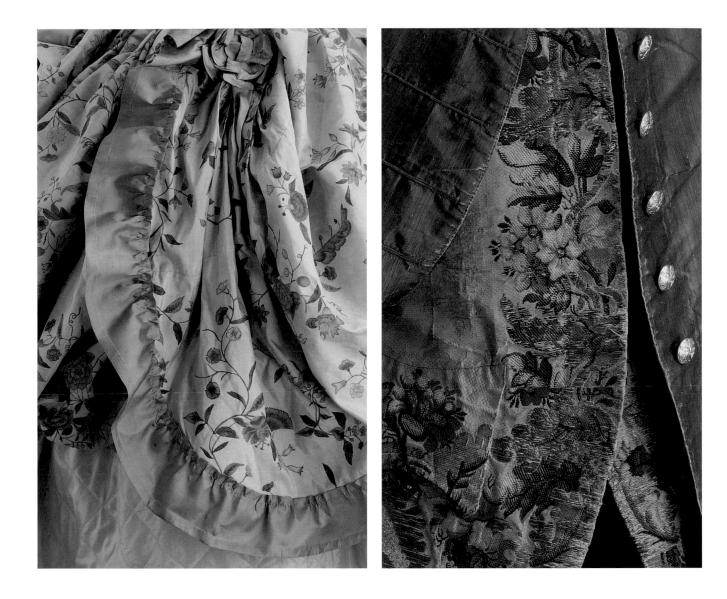

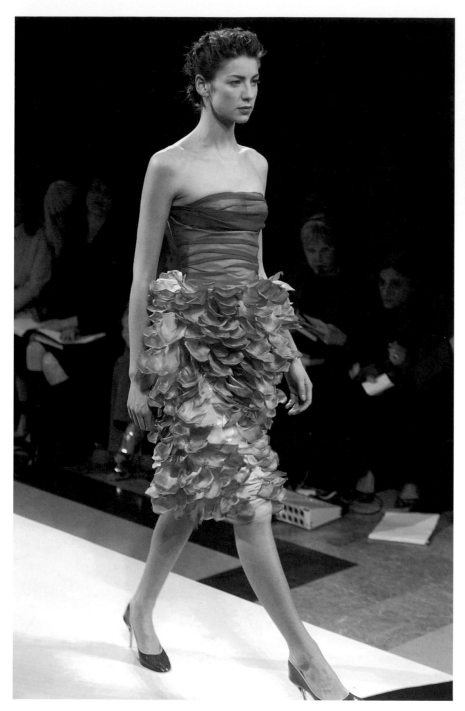

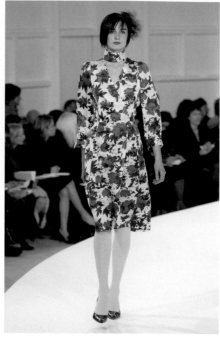

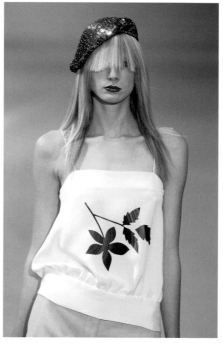

(Above)
Rochas by Olivier Theyskens *Autumn-Winter 2003-04.*

(Top)
Dries Van Noten *Autumn-Winter 2001-02.*

(Bottom)
Matthew Williamson *Autumn-Winter 2001-02.*

(Right)
Dirk Van Saene *White dress with floral photo print, Autumn-Winter 1995-96.*

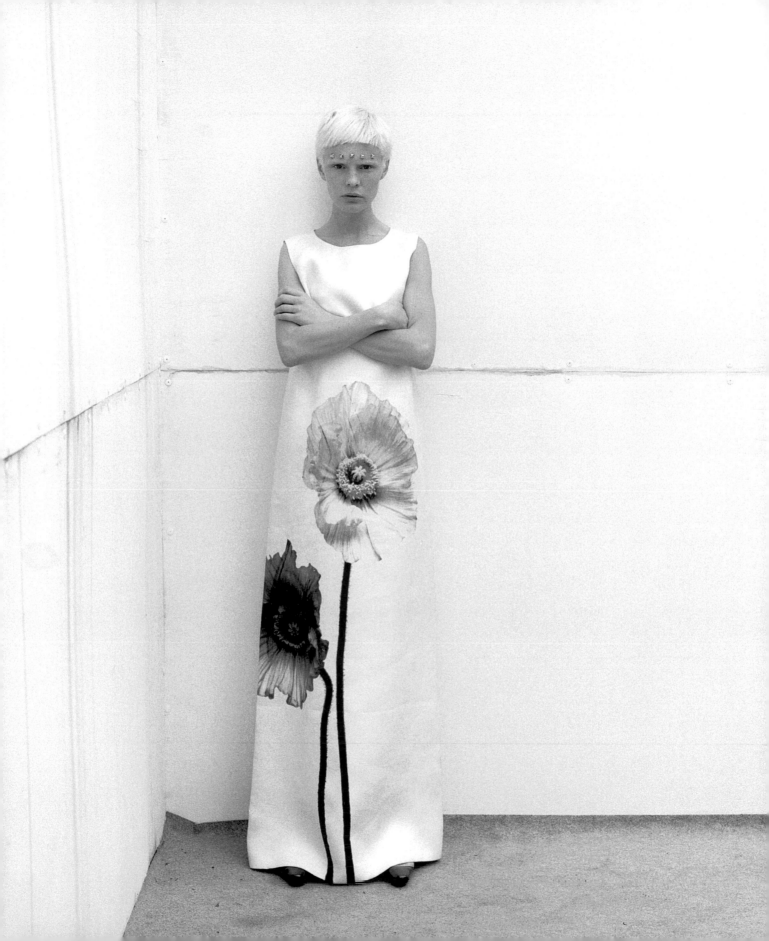

Genealogies are always infinite. Each section is just one possible route, a
way through to a different future. But links can be arbitrary or intended.
Different connections are always available.

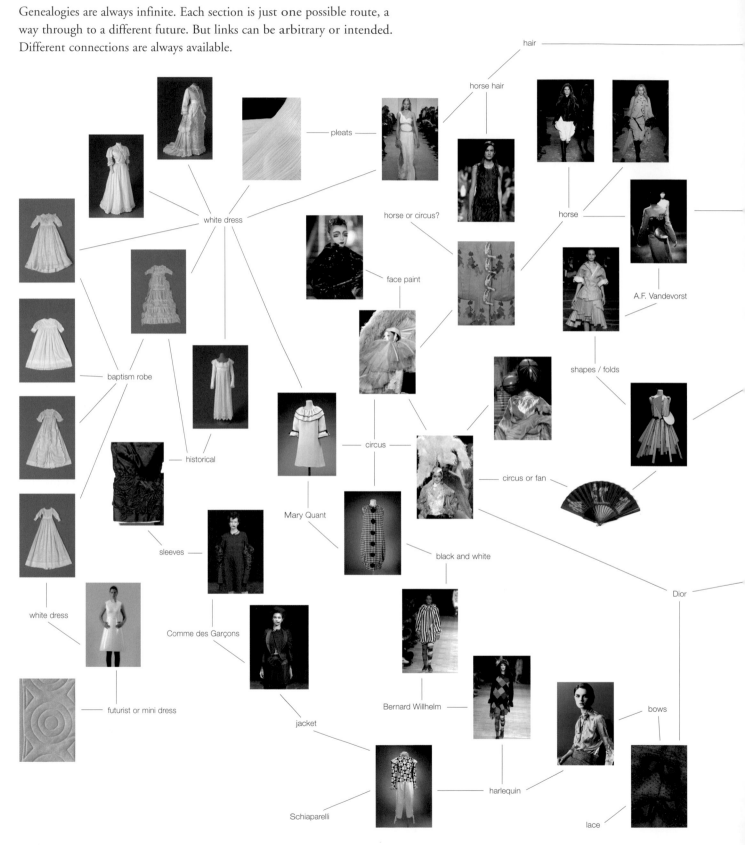

hair

horse hair

pleats

horse or circus?

face paint

horse

A.F. Vandevorst

shapes / folds

white dress

baptism robe

historical

circus

circus or fan

sleeves

Mary Quant

black and white

white dress

Comme des Garçons

Dior

futurist or mini dress

jacket

Bernard Willhelm

bows

Schiaparelli

harlequin

lace

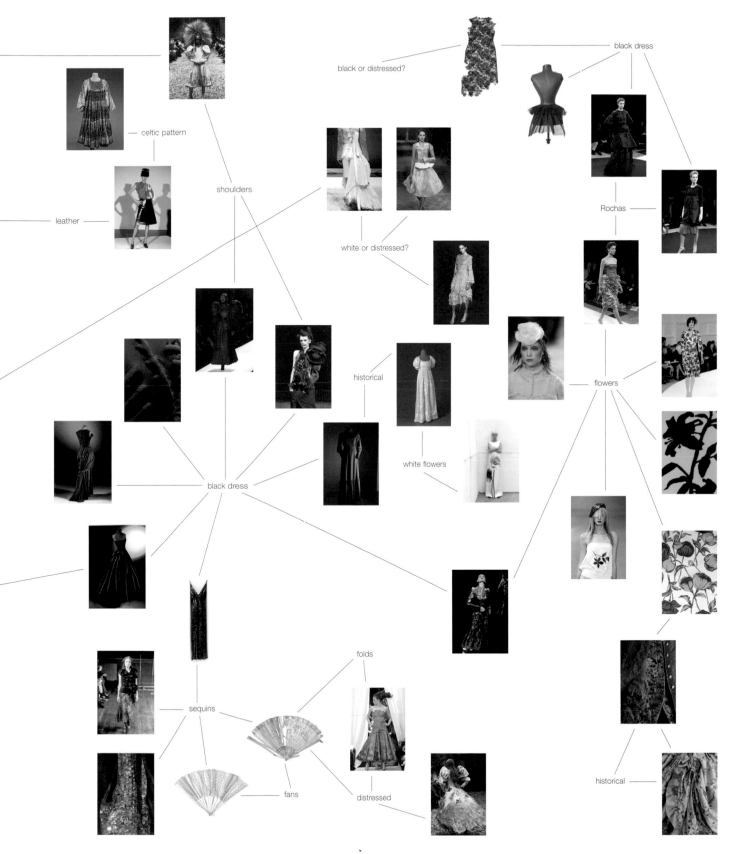

black or distressed?

celtic pattern

leather

shoulders

black dress

white or distressed?

historical

white flowers

black dress

sequins

folds

fans

distressed

black dress

Rochas

flowers

historical

Installation Malign Muses: When Fashion Turns Back

*

*Naomi Filmer, Ruben Toledo and Yuri Avvakumov
responded to the description of the project by the curator
with a view to moving it forward in different directions,
with distinct languages. November 2003 - June 2004.*

Naomi Filmer *June 2004*
'Phantasmagoria: The Amazing Lost and Found section.
Preparation sketch of harlequin feet to be made in wood.
Ballet shoes painted onto carved wood.'

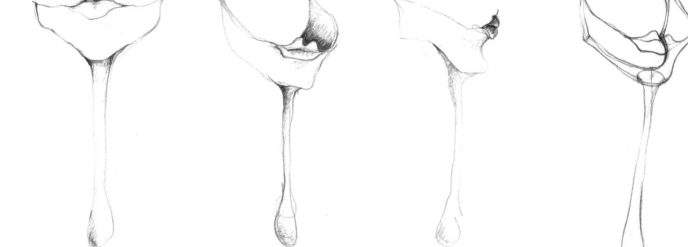

Naomi Filmer *June 2004*
'Phantasmagoria: The Amazing Lost and Found section. Masks to
be drilled onto Stockman mannequin neck. To be developed in fast
cast resins covered with white and Swarovski crystals. Hand to be
attached to mask, not to mannequin arm.'

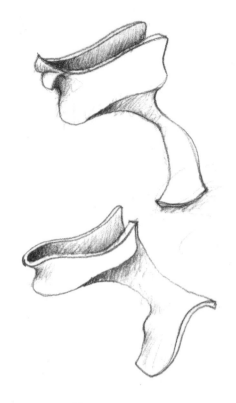

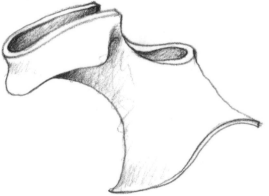

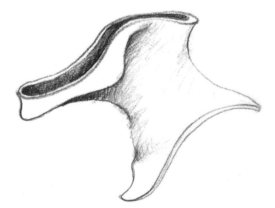

Naomi Filmer *June 2004*
'Locking In and Out section. Wax-like necks to be lowered onto traditional Stockman mannequin. Mould from Judith Clark Costume Gallery exhibition, 1999, to be re-used, incorporating the memory of our last collaboration.'

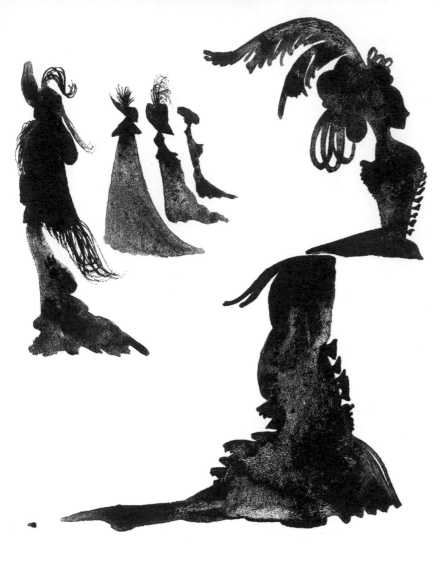

(Above)
Ruben Toledo *Out of Focus Reappearance, December 2003.*

(p.122)
Ruben Toledo *Fashion Machine, December 2003.*

(p.123)
Ruben Toledo *Idea for a giant spinning wheel of fashion, December 2003.*

(p.124)
Ruben Toledo *Avenue of Silhouettes, December 2003.*

(p.125)
Ruben Toledo *Nostalgia section, 'take a peek at this crinoline', December 2003.*

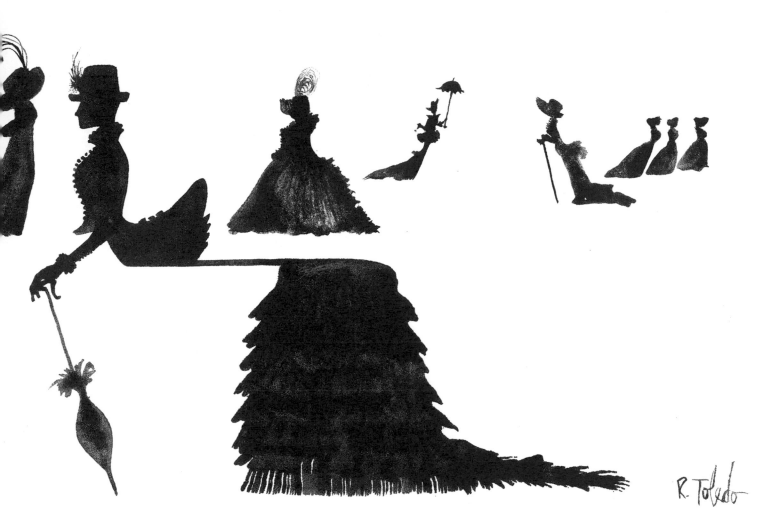

R. Toledo

Toledo loves fashion, but he is also wonderfully cynical in the
best sense of the boulevardier, the same role he assumes in life,
walking amidst the fashion world with a dandy's fascination
and poise. This Baudelairean hero imagines cities of silhouettes,
veggy ladies in the tradition of Grandville, and wondrous
wardrobes of sea, shell, idea, and armory. Toledo fulfills
Baudelaire's critical concept of the possibility of reconciling
the fugitive and the infinite. Toledo reports on a current style,
on a magazine's re-direction, on images that we can identify
to a specific time and season, but each becomes an image and
a perception more consequential than ephemeral.

Richard Martin

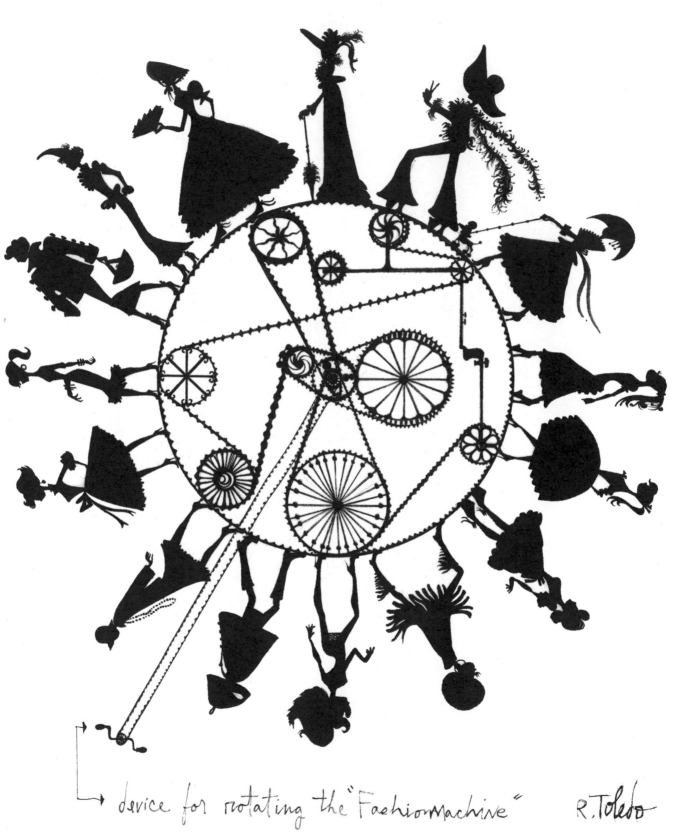

device for rotating the "Fashion machine" R.Toledo

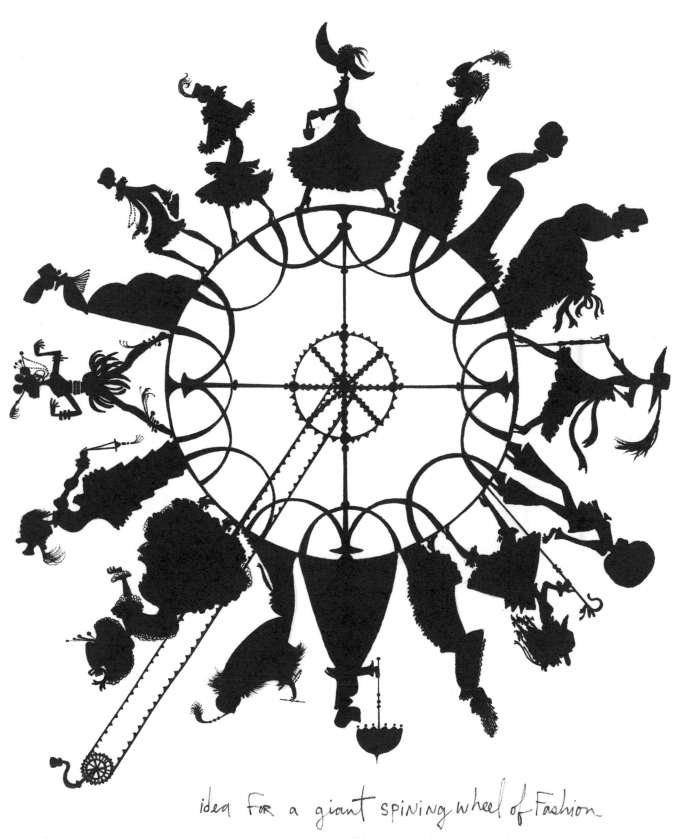

idea for a giant spining wheel of Fashion

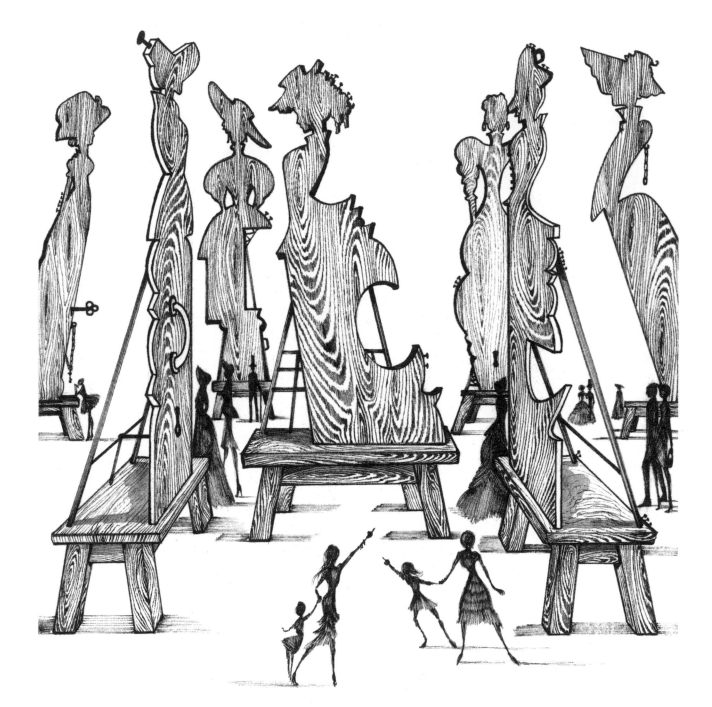

AVENUE of SILHOUETTES — ARCADE of the past

R.Toledo

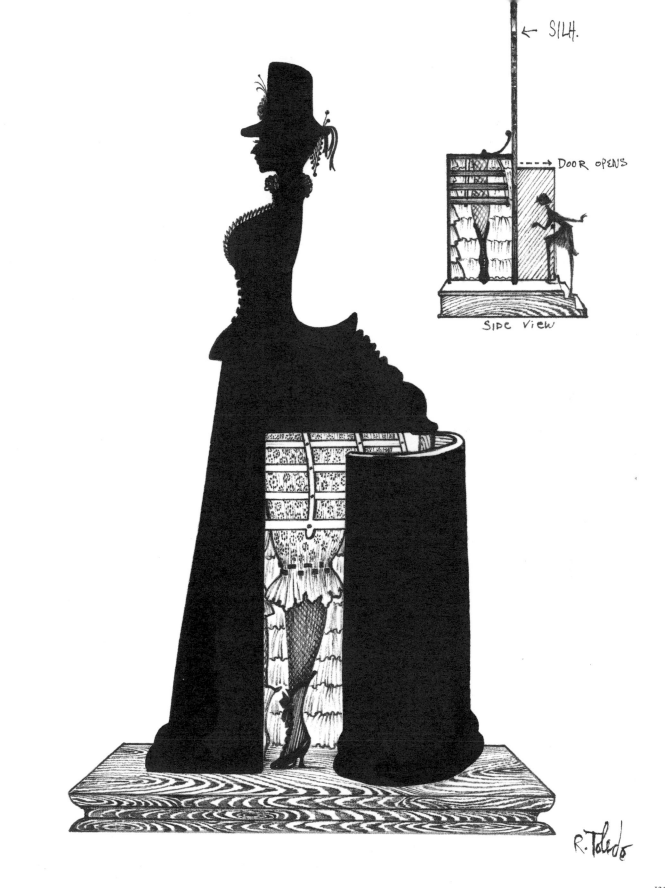

SILH.

DOOR OPENS

SIDE VIEW

R. Toledo

LES, LEST, LET, and FLYing ProLETarian*

YURI AVVAKUMOV

On 13 April 1919, the legendary Russian poet Velemir Khlebnikov issued an Appeal to Artists around the world to construct a world language of thoughts and signs, an 'alphabet of concepts'…

Khlebnikov's Appeal remained undeciphered by the world's artists, since firstly it was not translated into other languages (a complete edition of Khlebnikov's works was published only as recently as 1986), and secondly the creative linguistic concept it offered laid claim to the role of universal, yet was based on the individual, local traditions of Slav phonetics. An example of this is the theoretical thesis from Confirmations of Alphabet: 'Words beginning with L: *lodka, lyzhi, ladya, ladon', lopukh, lopast', lepestok, lasty, lyamka, iskusstvo leta, luch, log, lezhanka, prolivat', lit'*. We take a swimmer on a boat. The swimmer's weight is distributed over the broad surface of the boat. The point where force is exerted is spread over a wide area, and gravity makes it weaker as the area becomes wider. The swimmer is light. So L may be defined as a diminution of force at each point evoked by the increase in its application.' In a word-for-word translation into English we get a kind of senseless collection of words, as if for an IQ test: boat *(lodka)*, skis *(lyzhi)*, boat or castle/rook *(ladya)*, palm of hand *(ladon')*, burdock *(lopukh)*, blade/paddle *(lopast')*, petal *(lepestok)*, flippers *(lasty)*, strap *(lyamka)*, the art of flight *(iskusstvo leta)*, beam/ray *(luch)*, ravine *(log)*, bed shelf on Russian heating stove *(lezhanka)*, to pour through *(prolivat')*, to pour *(lit')*.

It is likely that, where a word-for-word translation changes the sense of the conceptual message of the original, the translator has to use another tool, like a mirror removed in space and time from the subject of the translation. This mirror may be another universal language different from languages of narration and the narratable, such as mythologic and morphologic languages. Thus, if outside architecture, a narrative about architecture is impossible by means of architecture alone; music and dance could usefully be employed, but more often than not we have to resort to 'the word, the Latin *verba*'. And there has to be a self-reporting system on how the architectural and the verbal concept will differ, like the original and the word-for-word translation. Much will of course depend on the translator. If rendered by an artist, the translation may contain parallel images which in fact transfer the original concept perfectly. The paradox is that the new concept will not be original.

*

LES [WOOD, FOREST]:

'a space covered with growing and mature trees' and an ancient mythologeme. Myths about woods and forests abound in the cultures of most of the peoples of the world and the forest is always (given some minor variations) a medium hostile to man. It is easy to get lost in the forest. *'Go into the forest – stare death in the face.'* The path through the forest leads to the world of the dead. The *forest* is populated by spirits, usually intermediary, somewhere between humans and the higher demons. In ancient times souls were like wild beasts (the depths of a forest are a refuge for beasts and dragons), then gradually popular imagination endowed them with human characteristics and the forest was transformed from the aggressive primordial material of chaos into a 'temple

of nature'. People learned not to fear the forest but to find practical uses for it, for example as a provider of building materials. 'The forest grew and so did the work of the axe', or, expressed another way, the Hero in popular culture defeats the Guardian of the Forest and uses the forest itself to build up his native city. As the city grows, so it itself becomes a forest and the town's inhabitants become wayfarers, obliged each day to blaze a path through the chaos of the 'concrete jungle'. The circle is closed.

<div align="center">*</div>

LESA [Scaffolding]:

temporary wooden structures (staging and stairs) used so that construction work can be carried out; originally made out of round or rough timber, from which it acquired its name in Russian. Scaffolding/timber has retained the magical nature of wood as well as its name. *'Where there are woods, there are wood-goblins.'* Under the protecting cover of scaffolding hides the utopian city of our dreams. Wooden scaffolding in the city is a constantly re-energising metaphor: the city as scaffolding/forests, and scaffolding/forests as the city. English scaffolding has emerged from the same timber as Russian, but it has other relatives: the French *echafot* and the Italian *catafalc*. *'That a scaffold of execution should grow a scaffold of coronation'* (Sir Philip Sidney). There is a theory, never confirmed, that when the stone churches in Old Russia were built, the architects did not use drawings but built them first out of wood, as a guide. Describing the creative output of the Cubists, Jean Cocteau remarked, 'While in times past a building may have been constructed with the aid of scaffolding, from now on, from 1912, it may be said that the artist can leave the timber and remove the building itself, especially since all architecture is preserved in the wood.'

<div align="center">*</div>

LESTNITSA [STAIRS]:

'gradual offshoot, stepped rise or descent; a connection of steps; two poles or polarised scaffold (bridgeboard or stringboard) with crosswise steps (ridges)'. The Russian word for stairs, *lestnitsa,* comes from wood/forest *(les)* or from climb/creep *(lezt')*. The tall tree in fairytales always signifies the 'stairway to the world above'.

Stairs as a wheel, that most ancient invention of humanity for communication. If a staircase or ladder is convolved into a circle, the result is a wheel. Two ladders nailed together into a cross is a sign of communicative embargo, a crossroads. A staircase often functions as a scale, a metric, giving the measurements of the universe along the vertical edge.

The stair joins the 'top' and the 'bottom', 'above' and 'below'; the stair starts at ground level and defines the direction of motion – up to the heavens or down to the underground. Several Ancient Egyptian mummies were found with miniature steps which souls could use to go up and down to the heavens. There are many different types of stairs in myths and fairytales: wooden, iron, gold, rope and stone. Cultures use references to different types of stairs: the front or grand staircase, back or service stairs, fire stair, career ladder, spiritual steps, punishment steps. In Russian, as in Italian, there is one word, *lestnitsa,* for stairs, be they a ladder and portable, or stone and stationary. In English and German these are regarded as different structures. The word we use to designate the desired culmination of sexual stimulus comes from the Greek word klimax, signifying stairway, the stairway to the heavens. Freud defined 'stairway' as 'coitus set in stone'. The stair is an integral component of construction scaffold, without which builders would never be able to move from level to level, people in a house would never get from floor to floor (storey to storey). In general, no construction is

possible without the Stair. Any building without walls will look like scaffolding – a skeletal structure with flights of steps. For the contemporary urban dweller, most of the mythopoetical ideas about stairways are lost, even discarded as useless. The city has deconsecrated the Stair. Nikolai Gogol's last utterance before death was 'The stair!'.

<p align="center">*</p>

LETAT [TO FLY]:

'to rush or float in the air, to move in airspace using one's own or outside power'. Winged creatures appeared, according to the Bible, on the fifth day of creation, while mankind appeared a day later. *'And God said, Let the waters bring forth the moving creature that hath life, and fowl that may fly above the earth in the open firmament of heaven.'* And though science tells us that the first flying creatures were insects, it has been man's dream to fly like a bird. The Gypsies have a legend: 'Our ancestors had wings, and then we lost the ability to fly. We are birds. When we look at a mountain we always want to be on its summit. But we have unlearned how to fly and we can only scramble slowly upwards. Some day we will have wings once more.' The problem of flight is almost as important as the problem of levitation (which does not require wings). The words 'fly' and 'levitate' sound quite similar in Russian. The Flying Boat, Wooden Eagle, Flying Carpet, the Russian magical horse Konyok-Gorbunok, the wicked sorcerer Chernomor, and the vampire-like witches known as 'willi', are a few examples of flying objects. One of the most exotic of flying personalities is Baba Yaga, the Slavic goddess of death. She flies in a *stupa* or mortar (*stupa:* Latin *mortarium; mortira;* Dutch *mortier*) using her pestle (made out of a tree) to steer it. Baba Yaga lives in the dense forest in a little hut on chicken legs. Since Russia is closer than most other countries to the Arctic, the ancient location of Hyperborea (according to Lucan, the inhabitants of Hyperborea had mastered the art and technology of flight; the diversity of this technology is incredible).

On the whole, though, it was gods who lived in the heavens, and since time immemorial humans have been striving with might and main to get there. In the decorative and fine arts, there are just as many images of mountains with people, towers, ziggurats and stairs as there are of Icarus and flying craft. In Russian the FLY-er is dreamer and the STAIRcase, whether cut like a metric into a rockface or hidden in a tower, is an imaginary substitute for wings as a means of transport. At the beginning of the twentieth century, one hundred and fifty million Russians were reaching for heaven on the crest of a socialist revolution. The artist Vladimir Tatlin designed a tower and a flying apparatus, the architect Georgii Krutikov designed a flying city, a proletarian vision of Swift's Laputa, and the poet Mayakovksky wrote the poem, *The Flying Proletariat*, in which Hyperboreal crowds of Bolshevik aviators defeat a Capitalist armada in the War of the Aeroplanes.

<p align="center">*</p>

PROLETARIAN:

(Latin proletarius, from proles – posterity, descendants) In our context, the broad (horizontal) masses of football fans, TV viewers (couch potatoes), urban dwellers, the voting public etc that make use of patrician (vertical) models of behaviour. Or, as Khlebnikov would have said, 'At the public level this thrust for change matches the change in Russia from duma (the old village council) to soviet, since the balance of power is spread out over an incomparably wider mass of power-holders: the swimmer, ie the state, is supported by a boat of broadly based people power.'

<p align="center">*</p>

*Even though the word-concepts given in the title have some obvious external similarity, they do not belong to the same etymological family and do not have a common root.

WOODs, WOODen hill of stair, and AERial proletARiat
*

Red Tower, 1992.

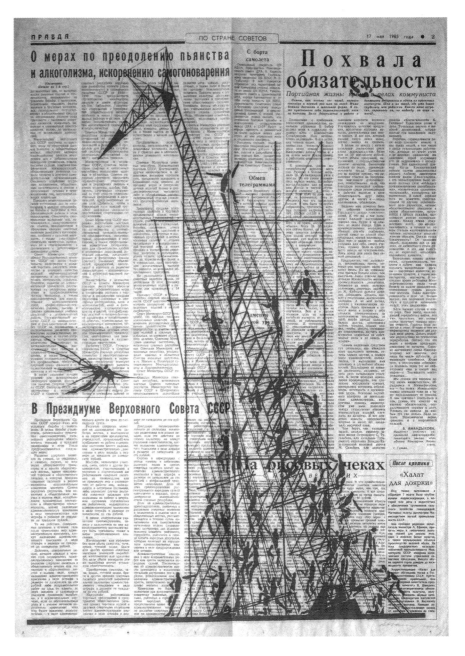

ЛЕСа, ЛЕСТНицы и ЛЕТающий проЛЕТарий.*

13 апреля 1919 года легендарный русский поэт Велемир Хлебников обратился к художникам мира с утопическим призывом о строительстве общемирового языка смыслов и знаков, "азбуки понятий"...

Обращение Хлебникова осталось художниками мира нерасшифрованным, так как, во-первых, не было переведено на другие языки (полное издание хлебниковских произведений было сделано только в 1986 году), а, во-вторых, представляло художественную лингвистическую концепцию, претендующую на роль универсальной, но базирующуюся на частных традициях фонетики славянских языков. Такой, например, теоретический тезис из "Утверждения азбуки": "Слова на Л: лодка, лыжи, ладья, ладонь, лопух, лопасть, лепесток, ласты, лямка, искусство лета, луч, лог, лежанка, проливать, лить... Возьмем пловца на лодке: его вес распределяется на широкую поверхность лодки. Точка приложения силы разливается на широкую площадь, и тяжесть делается тем слабее, чем шире эта площадь. Пловец делается легким. Поэтому Л можно определить как уменьшение силы в каждой точке, вызванное ростом ее приложения" - в дословном переводе на английский окажется бессмысленным набором слов теста на IQ: "boat, skis, palm, burdock, blade, petal, flippers, strap, art of fly, ray, ravine, stove bench, pour..."

Вероятно там, где подстрочный перевод меняет смысл концептуального послания, заложенного в оригинале, переводчику необходимо использовать другой инструмент, вроде зеркала, удаленного в пространстве и времени от объекта перевода. Таким зеркалом может стать какой-то другой универсальный язык, отличный от языков пересказа и пересказываемого, например, мифологический или морфологический.

Так, рассказ об архитектуре невозможен средствами самой архитектуры вне архитектуры; вероятно, музыка и танец были бы хороши, но чаще приходится пользоваться словом. И приходится отдавать себе отчет в том, что концепция архитектурная и вербальная будут отличаться, как оригинал и подстрочник. Многое, конечно, зависит от переводчика - если он художник, то в переводе могут быть найдены параллельные образы, адекватно передающие оригинальную концепцию. Парадокс заключается в том, что новая концепция уже не будет оригинальной.

ЛЕС - "пространство, покрытое растущими и рослыми деревьями" и древняя мифологема. Мифы о лесе можно найти у большинства народов мира и, несмотря на некоторые различия, лес всегда - среда, человеку враждебная. В лесу легко заблудиться. "Ходить в лесу - видеть смерть на носу". Через лес проходит путь в мир мертвых. Лес населен духами, чаще всего они посредничают между людьми и мифическими демонами. В глубокой древности духи были как звери (лес - "чащоба-прибежище зверей и драконов"), со временем в представлениях людей они очеловечились, а лес из агрессивной "первородной материи хаоса" был преобразован в "храм природы". Постепенно люди научились леса не бояться и находить в нем практическую пользу, например, добывать стройматериалы. "Вырос лес, так выросло и топорище" или, иначе выражаясь, культурный герой побеждает стража леса, а сам лес использует для строительства в родном городе. С ростом города уже он сам становится лесом, а городские жители уподобляются путешественникам, вынужденным ежедневно прокладывать свой путь в хаосе "каменных джунглей". Круг замыкается.

Лес - это деревья, деревья - это стволы, ветви и листья. Подробно распространяться о листьях не будем, заметим только, что лист - одно из хлебниковских слов на "л".

ЛЕСА - деревянные временные сооружения (подмостки и лестницы) для производства строительных работ - первоначально изготавливались из круглого или вчерне обработанного леса, откуда и получили в русском языке свое название. Вместе с названием леса сохранили и чудесную природу леса. "Был бы лес, будет и леший". Под покровом строительных лесов скрывается утопический город нашей мечты. Строительные леса в городе - постоянно действующая метафора города как леса и леса как города. Английские строительные леса хоть и вышли из того же леса, что и русские, родственников имеют других - французский эшафот (eschafaut) и итальянский катафалк (catafalco). That a scaffold of execution should grow a scaffold of coronation. --Sir P. Sidney.

Есть гипотеза, ничем не подтвержденная, согласно которой каменные храмы в Руси строились не по чертежам, а по предварительно выстроенным лесам, как по направляющим. Описывая творчество кубистов, Жан Кокто когда-то заметил: «если раньше здание сооружалось с помощью лесов, то отныне, с 1912 года, придется признать, что художник может оставить леса и убрать само здание, да так, что при этом в лесах сохранится вся архитектура».

ЛЕСТНИЦА - "ступенчатый всход, подъем или спуск; связь ступеней; две жерди (тетивы) с поперечными приступками (грядками)". Лестница тоже из леса, или от слова лезть. 'Высокое' (дерево) из сказки всегда значимо как 'лестница в верхний мир'.

Лестница как и колесо - древнейшее коммуникационное изобретение человечества. Если лестницу свернуть в круг, то и получится колесо. Две лестницы, сколоченные крестом - знак коммуникативного запрета, дорожный перекресток. Лестница - это шкала, задающая размеры вселенной по вертикали в универсальном смысле, и, обладая антропоморфной градуированностью (шаг ступени - один фут), приводящая в масштабное соответствие человека и пространство, в котором она размещена.

Лестница связывает "верх" и "низ", начало лестницы находится на земле, определяющее направление движения - вверх, на небо, или вниз, в подземный мир. У древних египтян при некоторых мумиях найдены миниатюрные лесенки, по которым души могли спускаться и восходить на небо. В мифах и сказках встречаются разные лестницы - деревянная, железная, золотая, веревочная, каменная. Человеческая практика различает лестницы черные, парадные, пожарные, карьерные, духовные, наказаний. В русском языке, как и в итальянском, одним словом "лестница" означены лестницы приставные, мобильные и каменные, стационарные. В английском и немецком - это разные конструкции. Слово, которое мы употребляем для обозначения желаемой кульминации сексуальной стимуляции, происходит от греческого klimax, означающего "лестницу", т. е. лестница на небеса. Фрейд толковал лестницу, как "застывший в камне коитус".

Лестница - неотъемная составляющая строительных лесов, без нее строителям не перебраться с уровня на уровень, обитателям дома - с этажа на этаж. Без лестницы вообще невозможно никакое строительство. Любое здание без стен выглядит как строительные леса - скелетообразная конструкция и лестничные пролеты. Для современного горожанина большинство мифопоэтических смыслов лестницы забыто за ненадобностью. Город десакрализует лестницу. "Лестницу!" - последнее слово Николая Гоголя перед смертью.

(Above)

LES, LEST, LET, original text, Yuri Avvakumov.

(Far right)

(in collaboration with Yuri Kuzin) *Tribune of a Leninist, 1987.*

ЛЕТАТЬ - "мчаться или плавать по воздуху, носиться в воздушном пространстве своею, либо стороннею силою". Летающие существа появились, как известно, уже на пятый день творения, в то время как человек - днем позже."И сказал Бог: да произведет вода живые существа; и крылатые да полетят над землею, по тверди небесной". И хотя, согласно науке, первые летающие существа были насекомыми, человеку, возмечталось летать подобно птицам. У цыган есть легенда: "Наши предки имели крылья, а потом мы потеряли способность летать. Мы – птицы. Когда мы смотрим на гору, мы всегда хотим оказаться на вершине. Но мы разучились летать и нам остается только медленно карабкаться наверх. Когда-нибудь мы снова обретем крылья". Проблема полета почти так же важна, как проблема левитации, не требующей крыльев. Летать и левитировать по-русски звучит почти одинаково. Летают Летучий корабль, Деревянный орел, Ковер-самолет, Конек Горбунок, Черномор, Вилы и многие другие. Один из самых экзотичных летающих персонажей - славянская богиня смерти Баба Яга. Она летает в ступе (ступа (лат.) – mortarium, мортира (голл.) - (mortier), управляя помелом, макетом дерева. Баба Яга живет в дремучем лесу в избушке на курьих ножках. Поскольку Россия ближе других стран к Антарктике, где когда-то располагалась Гиперборея, народ которой по Лукиану владел техникой воздухоплавания, такое многообразие техник неудивительно.

В основном же Боги обитают на небесах, куда человечество стремилось с незапамятных времен всеми силами. И поэтому в изобразительном искусстве изображений населенных людьми гор, башен, зиккуратов и лестниц, достигающих неба, не меньше, чем икаров и крылатых кораблей. Летатель в русском языке - мечтатель, а лестница (прорезанная в скале или спрятанная в башне) - воображаемая замена крыльям как транспортному средству. В начале XX века на волне социалистической революции в небо устремилось 150.000.000 россиян. Художник Владимир Татлин спроектировал и башню и летательный аппарат, архитектор Георгий Крутиков - летающий город, пролетарскую иллюстрацию Лапуты Дж. Свифта, а поэт Владимир Маяковский написал поэму "Летающий Пролетарий", в которой гиперборейские эскадрильи большевистских летчиков побеждают капиталистическую армаду в войне аэропланов.

ПРОЛЕТАРИИ (лат. proletarii, от proles - потомство) в нашем контексте - широкие (горизонтальные) массы футбольных болельщиков, кинозрителей, горожан, избирателей и т.п., использующие патрицианские (вертикальные) модели поведения. Или, как сказал бы Хлебников: "В общественном строе такому сдвигу отвечает сдвиг от думской России к советской России, так как новым строем вес власти разлит на несравненно более широкую площадь носителей власти: пловец – государство – (опирается) на лодку широкого народовластья".

*Несмотря на очевидное внешнее сходство, приведенный в заглавии ряд слов-понятий, не принадлежит одному этимологическому семейству и не имеет общих корней.

Юр. Аввакумов

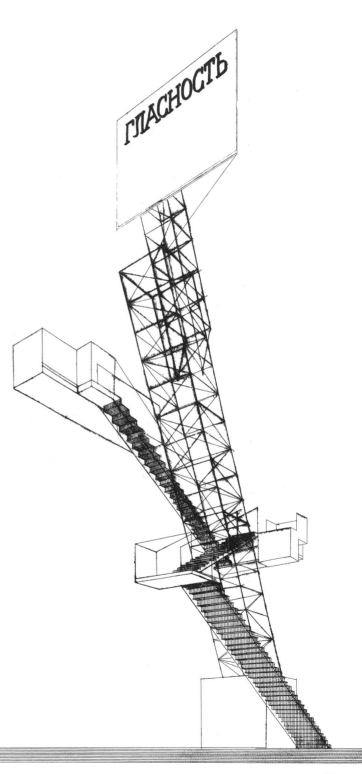

Avvakumov's appropriation of the Constructivist idiom is, in typical postmodernist manner, self-consciously superficial and ironic. From a unified amalgam of ideology, theory, and aesthetics, so characteristic of the original Russian avant-garde, he distills only Constructivism's expressive, decorative aspects… he removes the pathos of the Soviet architectural pioneers, in his belief that Constructivism is "a language not only for composing legends and writing hymns, but also for telling fairy tales and jokes."

Scaffolding and fire-escape ladders are favourite construction elements of Avvakumov. "A ladder is one of the first human inventions; it probably precedes the wheel" he claims. "Yet its expressive potential is far from exhausted."

Quote from *New Russian Design*, Constantin Boym, Rizzoli International Publications, 1992

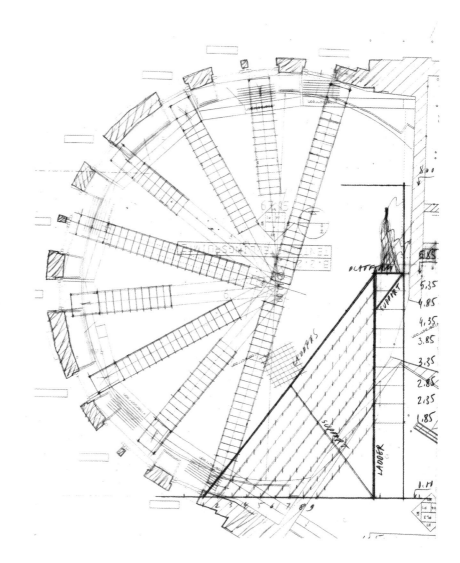

(Above)
Yuri Avvakumov *Nine Ladders, July 2004.*

(Right)
Yuri Avvakumov *Six Ladders, July 2004.*

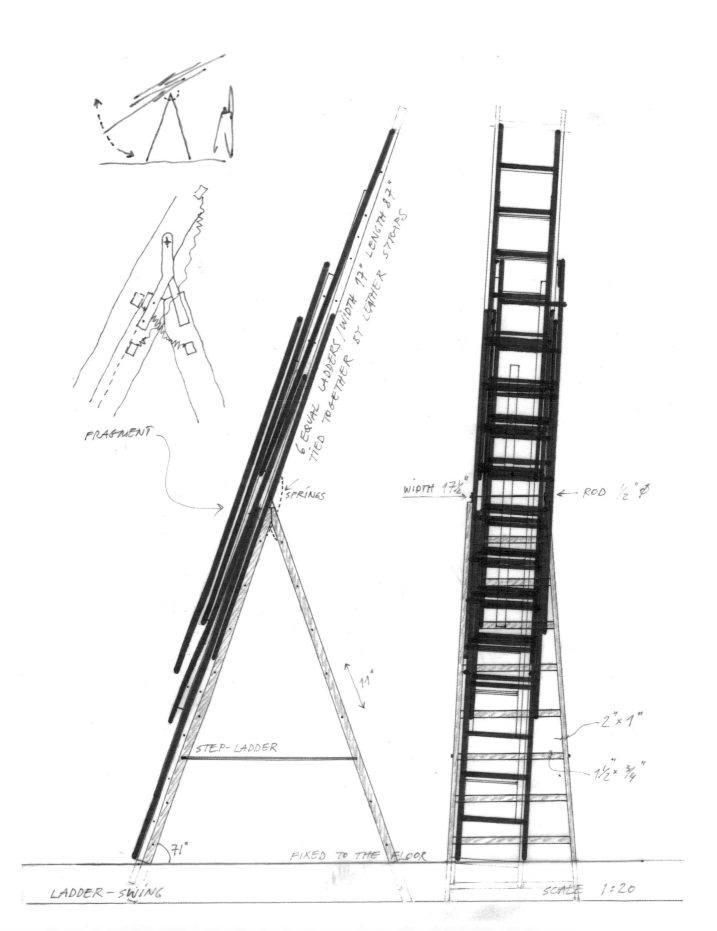

FRAGMENT

SPRINGS

6 EQUAL LADDERS / WIDTH 17" LENGTH 87"
TIED TOGETHER BY LEATHER STRAPS

WIDTH 17½"

← ROD ½" ø

11"

STEP-LADDER

2" × 1"

1½" × ¾"

71°

FIXED TO THE FLOOR

LADDER-SWING

SCALE 1:20

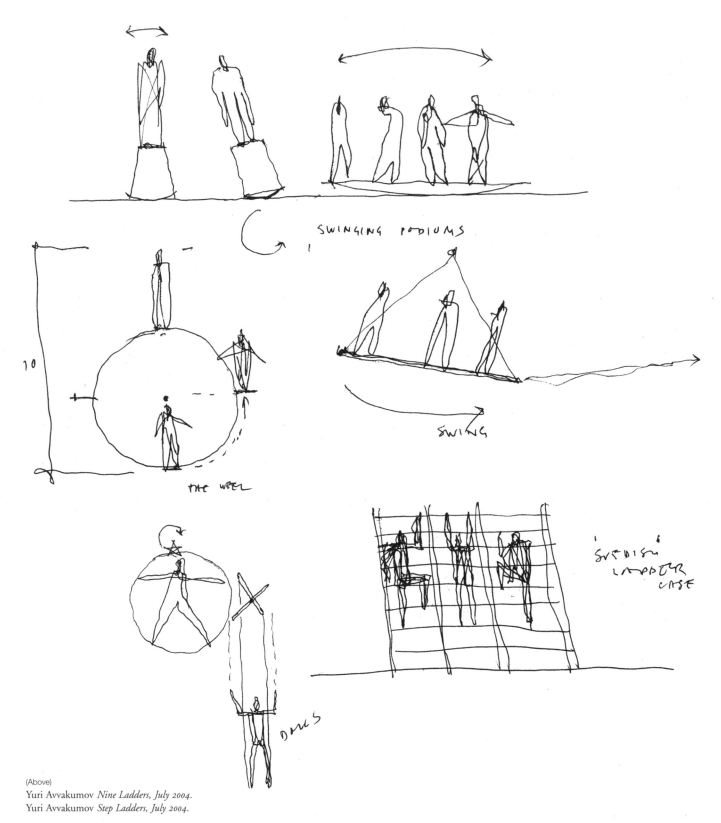

SWINGING PODIUMS

THE WHEEL

SWING

SWEDISH LADDER CASE

DOLLS

(Above)
Yuri Avvakumov *Nine Ladders, July 2004.*
Yuri Avvakumov *Step Ladders, July 2004.*

(Right)
Yuri Avvakumov *Sketchbook, Exhibition Sections, Notes, November 2004.*

① HISTORY

PAST ← ATTICS □□ LABYRINTH !

MIRROR?

② NOSTALGIA (HOPING FOR THE PAST)
RAISED AND MONUMENTALIZED
(1 FIGURE?)

③ PAST RELEVANCE

COLLAGES

④ PHANTAZMAGORIA
EXTREME PROPORTIONS, CIRCUS FIELD
FAKE HISTORY MASKS
 CUTOUTS

⑤ 'REMIXING THE PAST'
SECOND - HAND SHOP RETRO
JIGSAW PUZZLES, CHILDISH GAME,

⑥ TRAUMA
FUTURE RUINS

(Left; top to bottom)
Judith Clark *Sketch*, Yuri Avvakumov *Sketch*, Yuri Avvakumov *Sketch*, *Antwerp exhibition space layout plan, November 2003*.

(Above right)
Yuri Avvakumov *Sketch*, *ModeMuseum exhibition space layout plan, November 2003*.

(Below right)
Ercola Production Company *Computer drawing of exhibition layout, June 2004*.

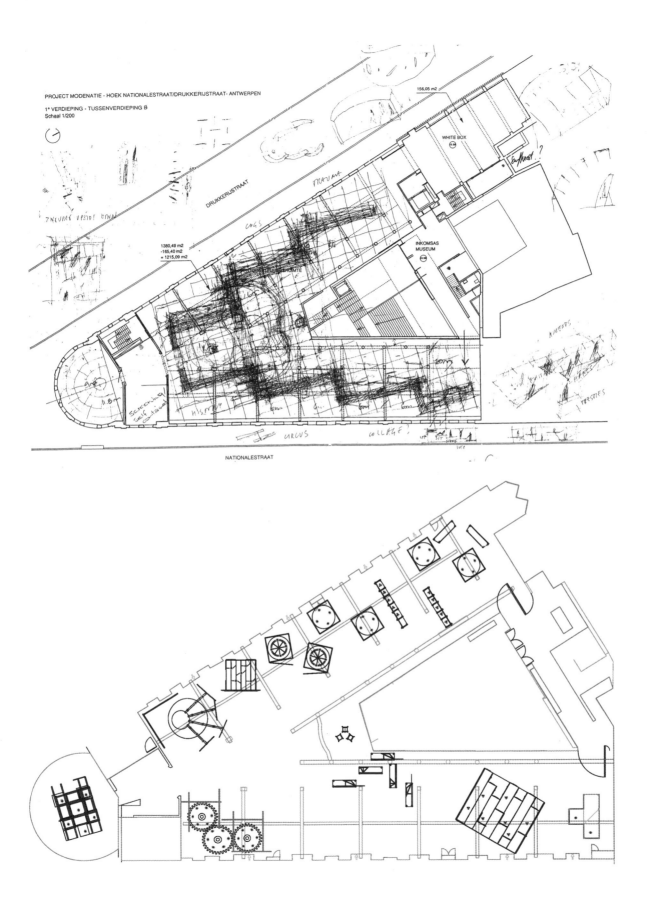

PROJECT MODENATIE - HOEK NATIONALESTRAAT/DRUKKERIJSTRAAT- ANTWERPEN

1° VERDIEPING - TUSSENVERDIEPING B
Schaal 1/200

DRUKKERIJSTRAAT

156,05 m2

WHITE BOX

1380,49 m2
-165,40 m2
= 1215,09 m2

INKOMSAS
MUSEUM

NATIONALESTRAAT

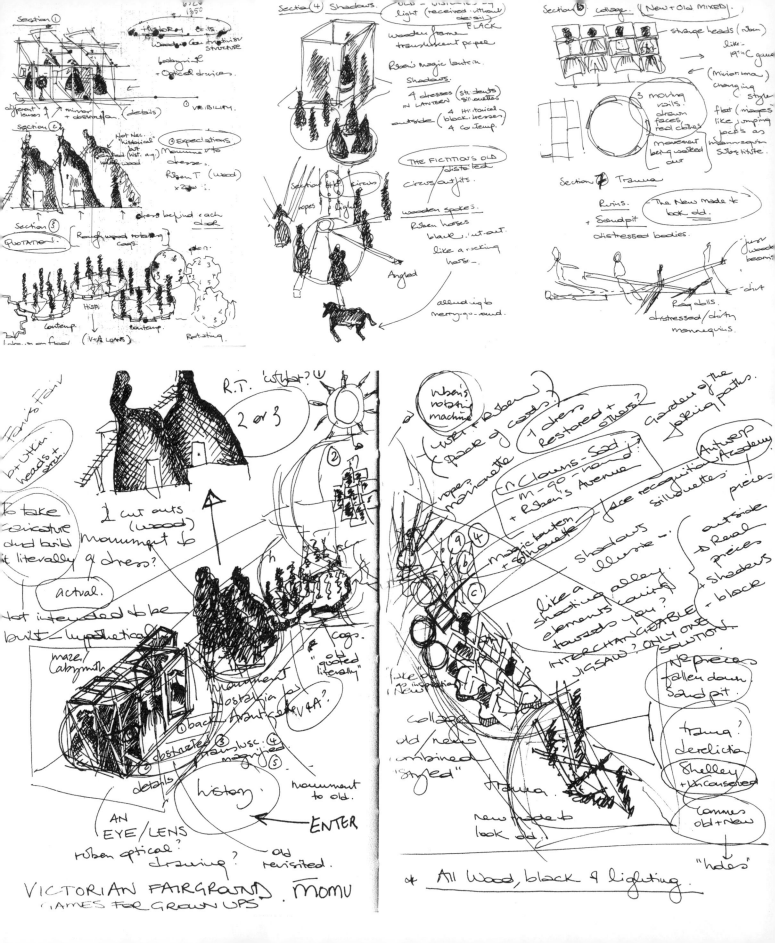

(Left)
Judith Clark *Pages from sketchbook, April 2004.*

(Right)
Photographs of exhibition, balsa-wood maquette, July 2004.

(Below right)
Ercola Production Company *Workshop, Antwerp, July 2004.*

(Below)
Judith Clark *Design for Locking In and Out section, February 2004.*

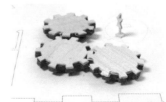

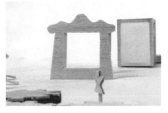

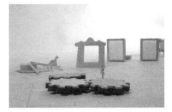
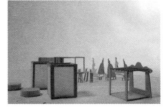
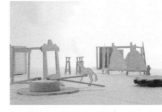
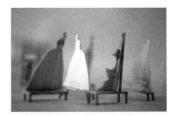
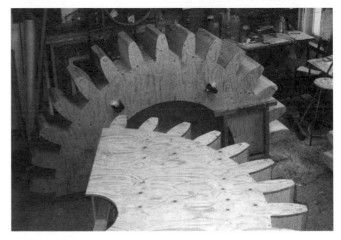

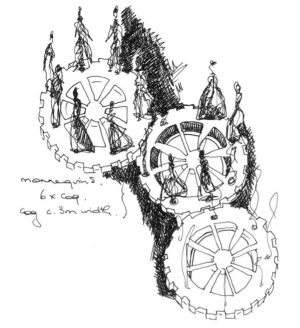

mannequins.
6 x cog.
cog c. 3m width.

Ruben Toledo *Patterns for wooden silhouettes, Nostalgia section, July 2004.*

Ercola Production Company *Workshop, Antwerp, July 2004.*

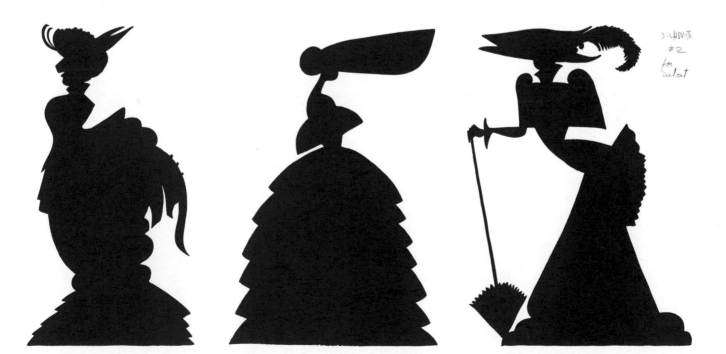

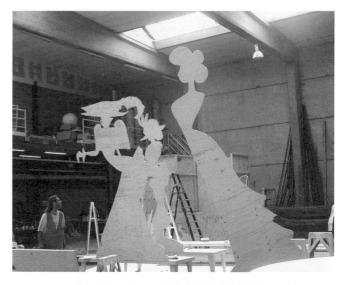

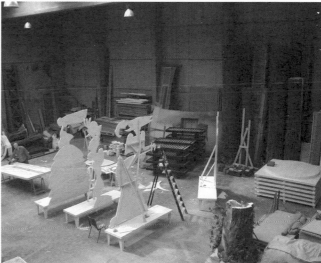

Silhouette
4

for
cut
out
(may be too
difficult
because of
ZIG-ZAG
fur
area

see
alternate
silhouette)

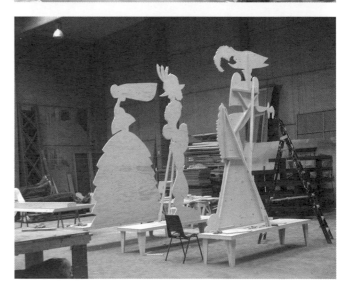

basic stud work in plywood.

being chairs for dist. eject.

(labyrinth marked on floor

Irregular planks of wood

hole to look at 'edited history'

MDF painted Black cut out nailed to wood. D 1" thick? each with eye hole but different design. (R.Toledo)

2 metres.

Section!

1m.

× 7 Eye holes.

Section.

① REAPPEARANCES : GETTING THINGS BACK.

combining the idea of the labyrinth, where the past reappears within a closer where it resonates with the present creating multiple folds in time

the idea that we look back at a distorted past — one without context — through 'modern' eyes.

About looking at the past, / Editing, obstructing, selecting.

mannequins stand on labyrinth drawn on floor

basic wood countin

to re basic modu

Seven optical devices "decorated" with Esher's eyes

Section

R.T. cut out.

writes backs through 'eyeball' onto distorted detail.

panorama/labyrinth of dresses — we can't get close, or walk in, but they are all visible from the side.

Judith Clark *Installation design, Reappearances section, April 2004.*

Ruben Toledo *Eye detail, Sketchbook, October 2003.*

Ruben Toledo *Patterns for merry-go-round horse and
teacup, Phantasmagoria section, August 2004.*

Tea CUP for Carasel — Merry go Round R. Toledo

Horse for Merry go Round R. Toledo

The Exhibition

✳

This section shows photographs taken of the exhibition
Malign Muses: When Fashion Turns Back, *MoMu Antwerp,*
18 September 2004 – 30 January 2005.

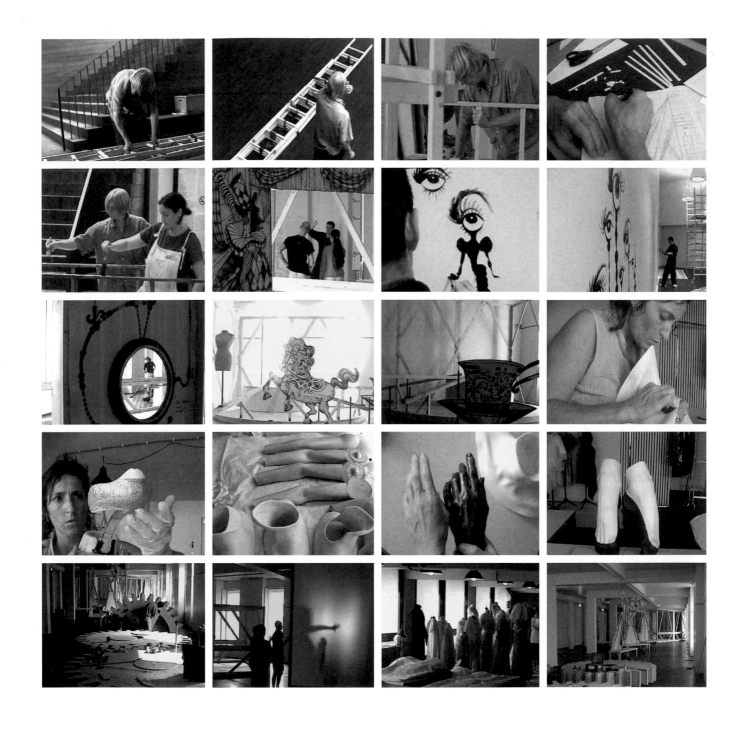

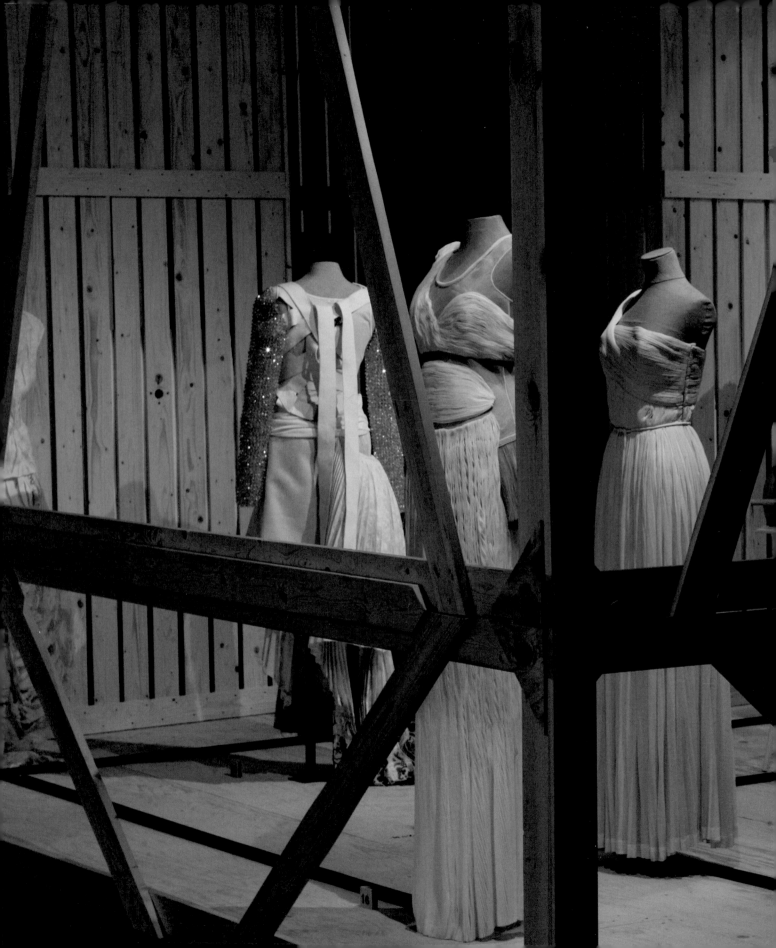

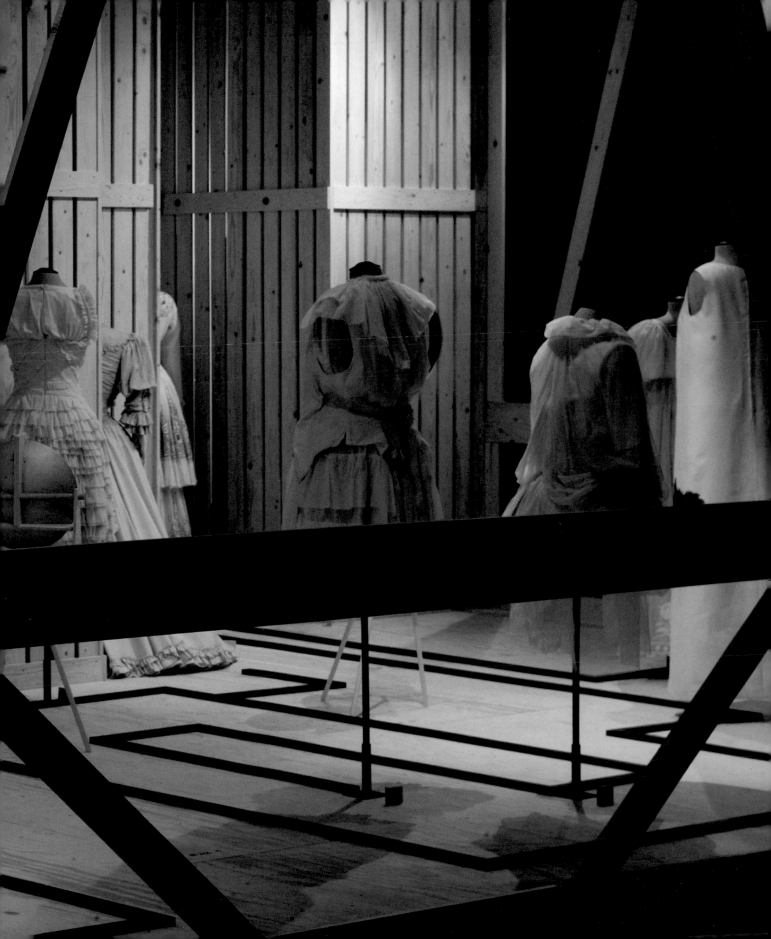

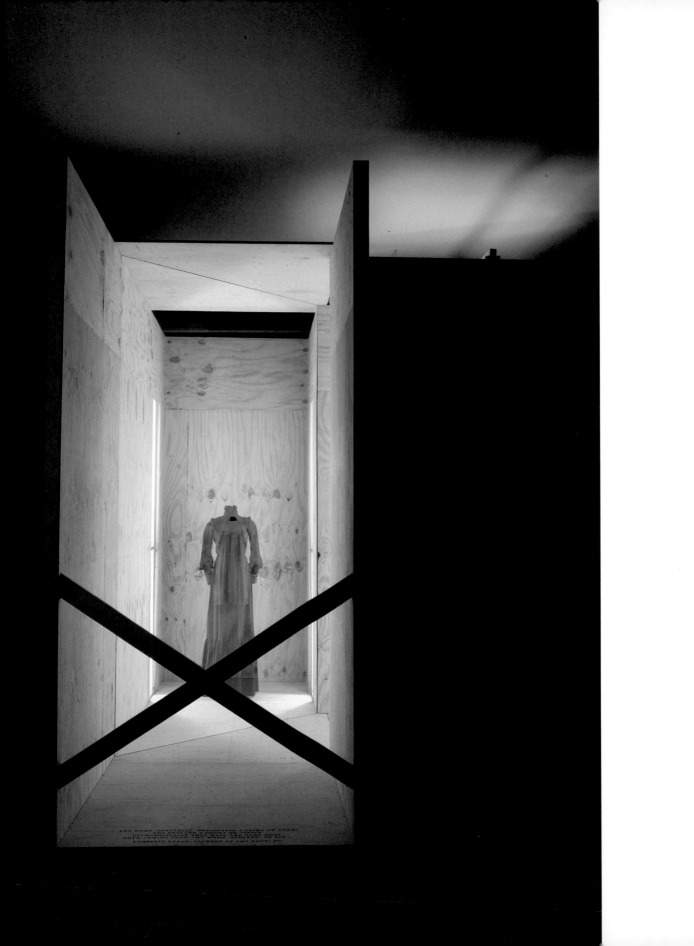

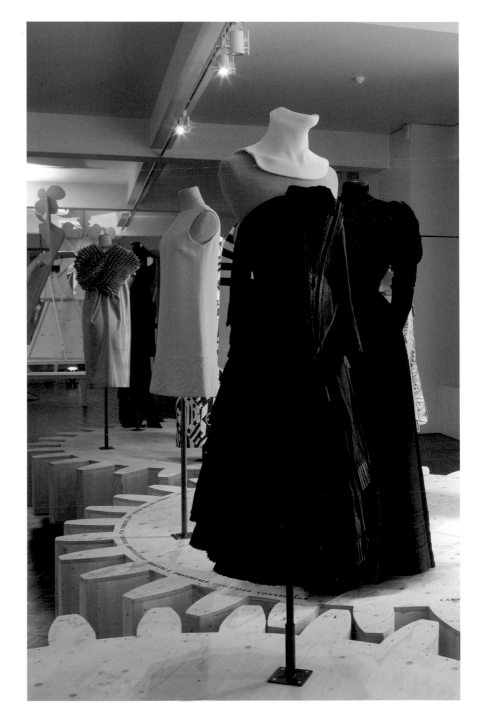

151

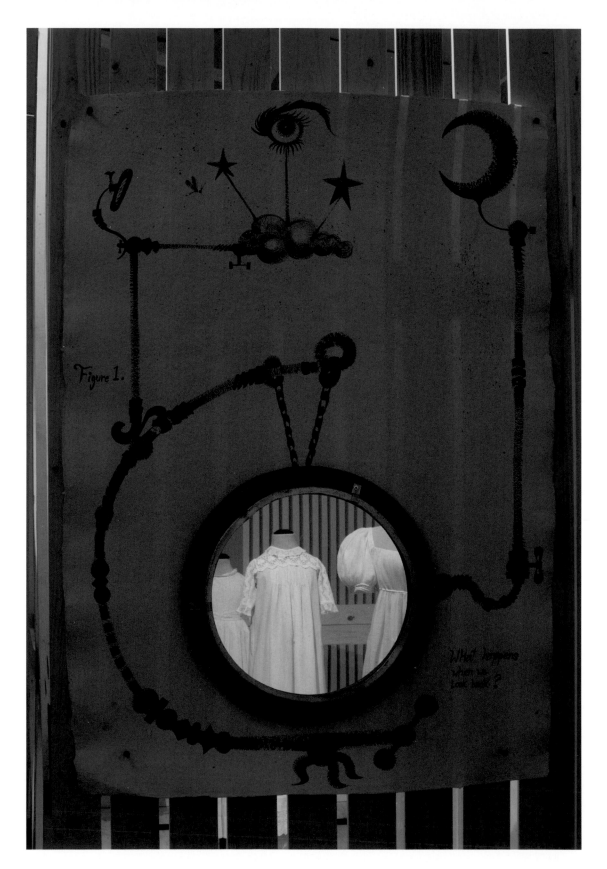

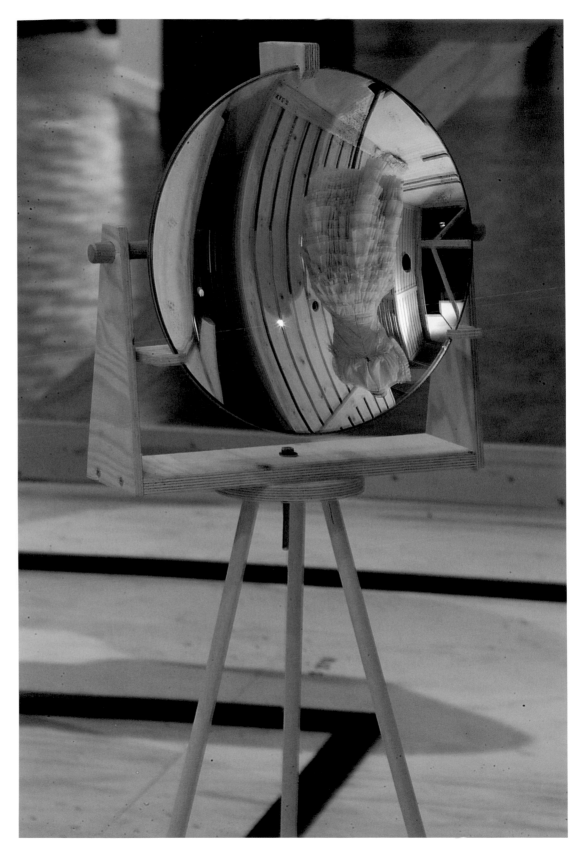

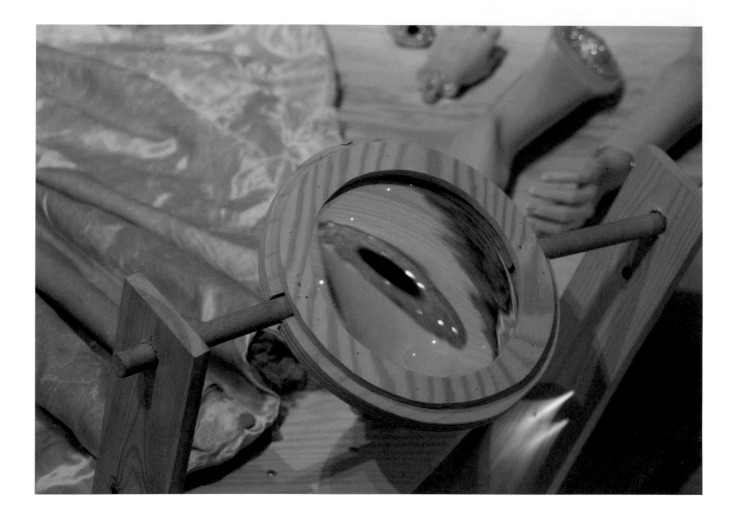

(Previous spread, pp.152-153)
Reappearances: Getting Things Back.
Details of the Labyrinth.

A New Distress.
Detail of magnifying glass.

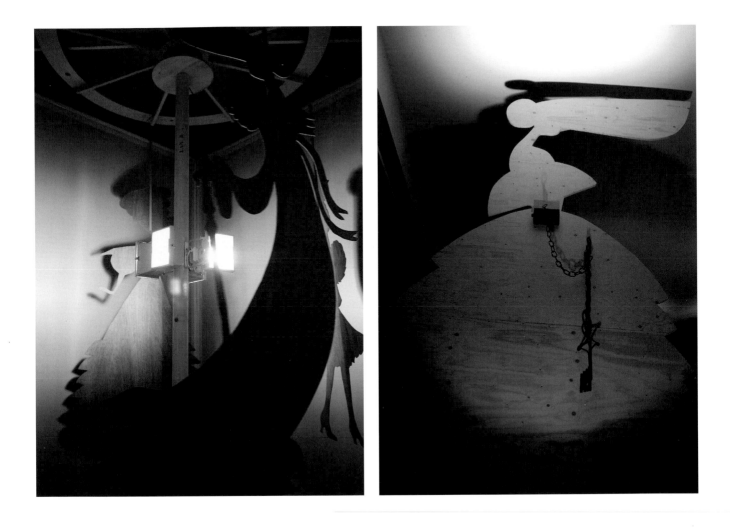

(Above)
Phantasmagoria: The Amazing Lost and Found.
Inside detail of the magic lantern.

(Above right)
Nostalgia.
Detail of the 'Avenue of Silhouettes'.

(Following spread, pp.156-157)
'Curiouser and Curiouser'
Alice's Adventures in Wonderland, The Pool of Tears.
Curiosity cabinet.

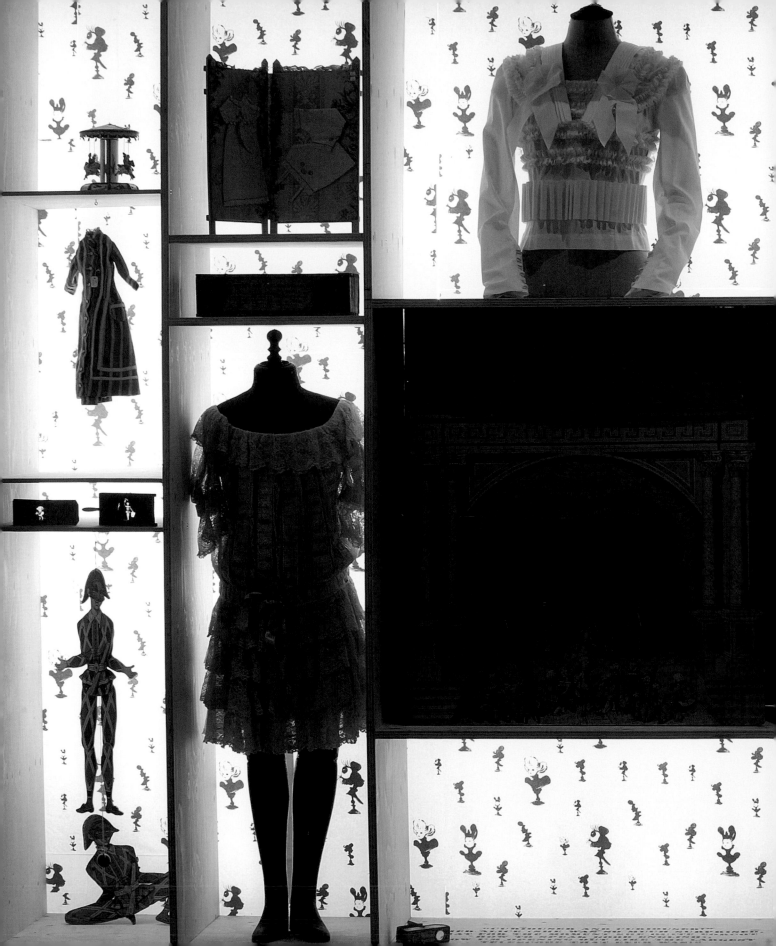

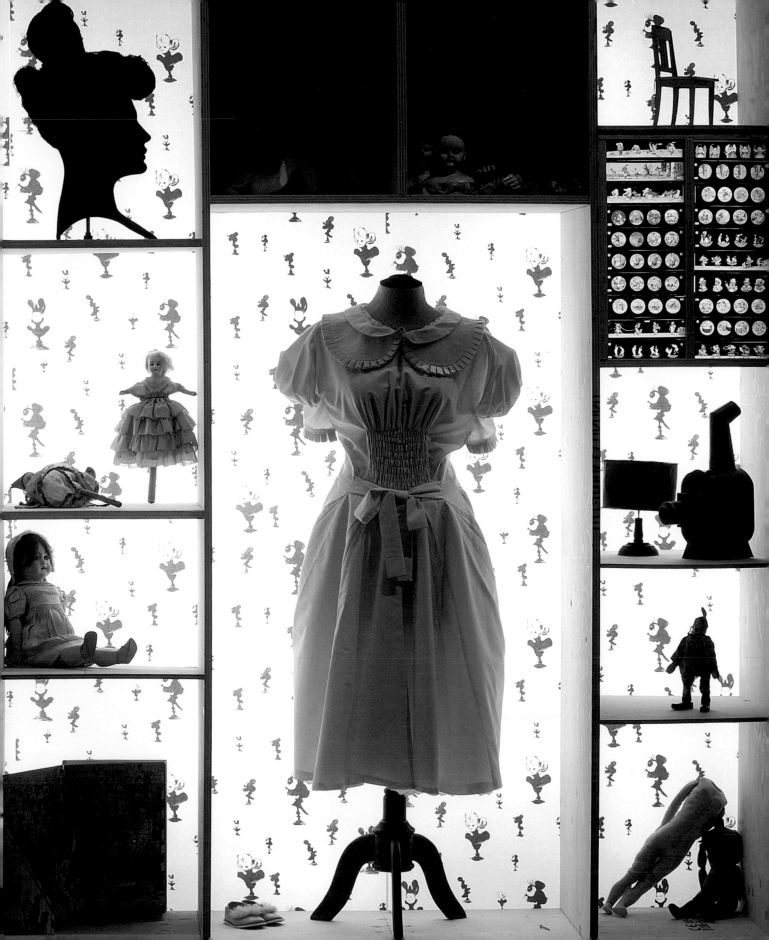

(Right)
'Curiouser and Curiouser'
Alice's Adventures in Wonderland, The Pool of Tears.
Detail of the curiosity cabinet.

(Below)
Remixing It: The Past in Pieces.

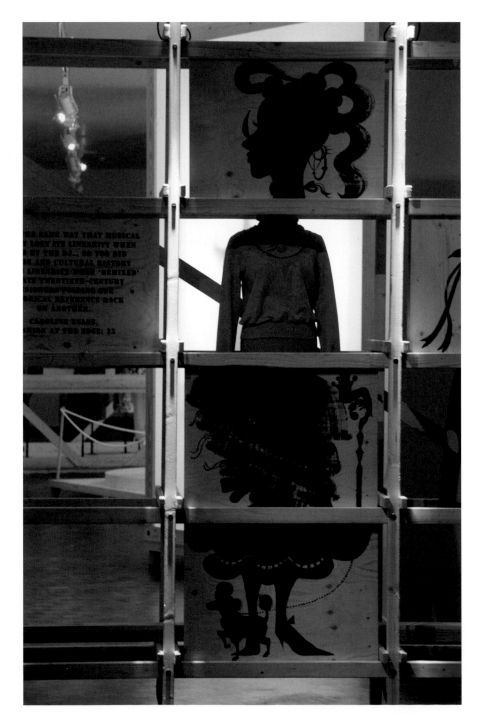

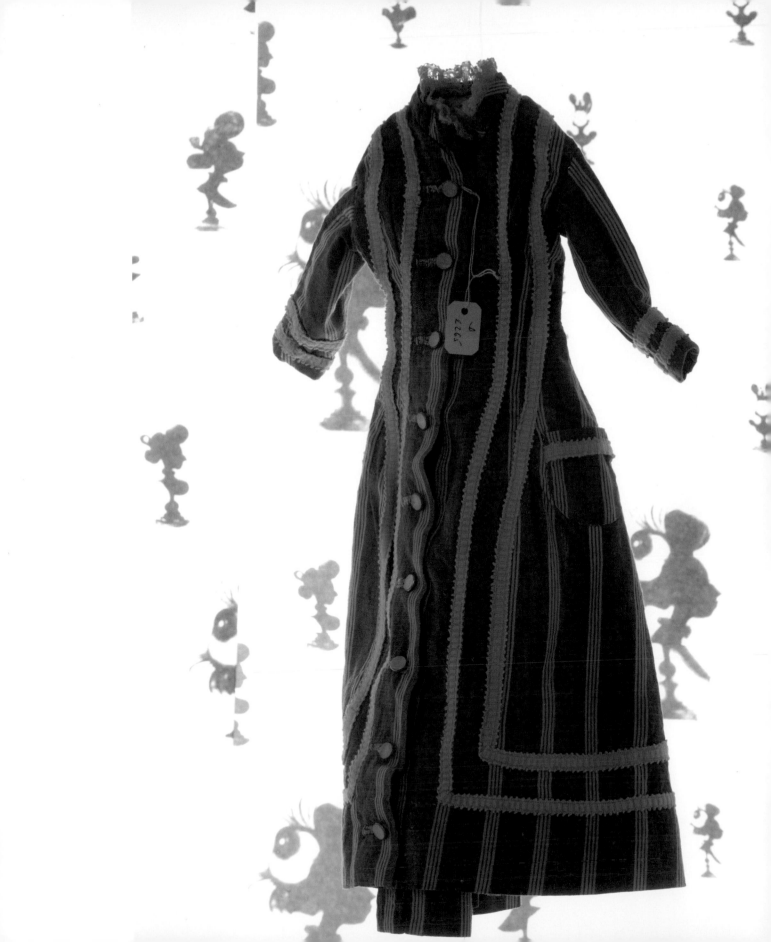

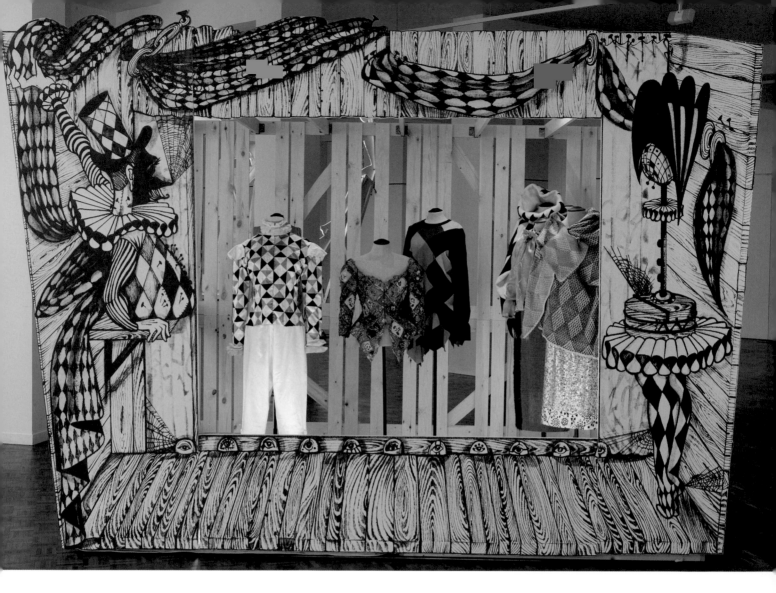

(Above)
Phantasmagoria: The Amazing Lost and Found.
Marionette theatre.

(Right)
Phantasmagoria: The Amazing Lost and Found.
Merry-go-round.

(Following spread, pp.162-163)
Garden of the Forking Paths.

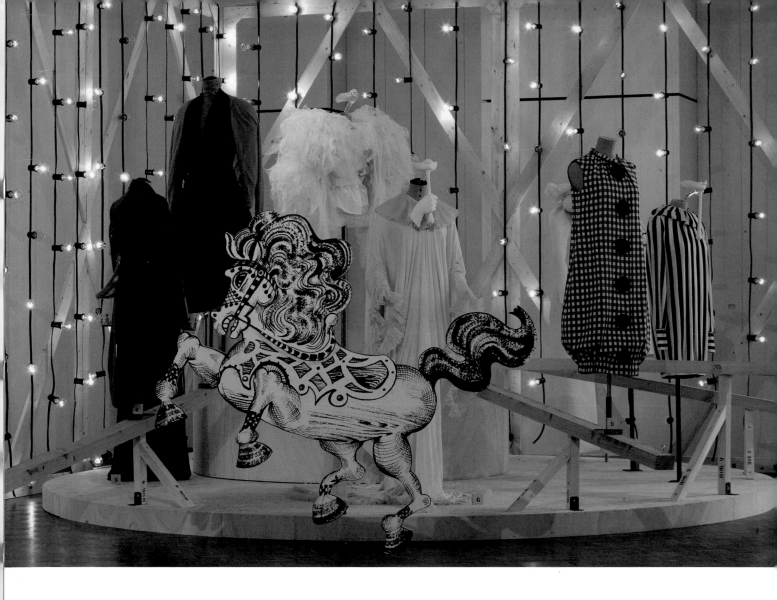

Acknowledgements

Linda Loppa at ModeMuseum, Antwerp, commissioned this project. She gave me carte blanche to create an exhibition as a work in progress. This never usually happens and I am very grateful to have had this remarkable opportunity.

When I started my post at London College of Fashion/Victoria and Albert Museum as Fellow in Contemporary Fashion, my work on this exhibition had already begun; I am grateful for having been given the opportunity to devote time to this during my time at these institutions.

I am indebted to Sandra Holtby at London College of Fashion for her investment in this collaboration between three institutions.

Christopher Breward has always been my first port of call. As Head of Research at London College of Fashion, and now as Deputy Head of Research at the Victoria and Albert Museum, he has made sure ideas have translated into proposals, smoothed procedures, and, consistent with this, at a very important moment improved this volume with his clear and elegant writing.

The importance of Caroline Evans's theoretical writing and the generosity and freedom that she granted me to browse her ideas is documented in Chris Breward's introduction, but it does not document what it has meant to me personally to work with her and the importance of her work to me. Our conversations are very dear to me.

Ruben Toledo worked far beyond his contractual brief, producing a wealth of material that had to be included. Work of this quality could not be omitted. Yuri Avvakumov has contributed his unique and idiosyncratic style to this project – it has been an honour to be able to include his work. Naomi Filmer as a friend, collaborator and a jeweller has been essential to my conception of this exhibition – her work tells its own story. As ever I have relied on Charlie Smith's capacity for work at the last minute; every page of this book reflects her flair for design. Calum Storrie introduced me to the idea of Pepper's Ghost.

In Antwerp, my thanks particularly to Kaat Debo, who has led me through designers' pieces and made important in-situ improvements to the exhibition overall, and Annelies Verstraete, who had to combine different stylistic languages into a buildable set.

The two Heads of Research at the Victoria and Albert Museum, Mark Haworth-Booth and Carolyn Sargentson, have supported my time in the Research Department, as have Claire Wilcox, Carol Tulloch and Vicki Coulson.

Susan McCormack and Lauren Parker from the Contemporary Team have supported the translation of the project into something that the Victoria and Albert Museum could host. My thanks also to Christopher Wilk, Linda Parry, Sonnet Stanfill, Sue Prichard and Suzanne Smith from the Furniture, Textiles and Fashion Department; Lara Flecker from the Conservation Department; and most importantly Louise Shannon, who has quite literally propped up this exhibition with her always prompt and astute contributions both during the research stage and the installation in Antwerp.

For this book, I am grateful to Mary Butler, Head of V&A Publications, Rachel Connolly as editor, and Geoff Barlow, who has managed the project, for their support and for helping this project to reach a wide audience.

There are two designers whose presence in this book does not do justice to their contribution: Simon Thorogood, with whom I have worked for three years and benefited from his conversation during our many lunches throughout his post as London College of Fashion Designer in Residence at the Victoria and Albert Museum. It has always been an inspiration to me to watch him work. And Shelley Fox, who has been generous in sharing with me her remarkable research material. Her work at Bethnal Green Museum of Childhood has been on my desk for the last year.

The illustrations in this book were improved by the eye of Marketa Uhlirova, assisted by Risa Puleo. The picture research has been supported by AHRB.

Finally, work on the book and the exhibition could not have been completed without: Katherine Clark, Tony Clark, Alessandra Grignaschi, Elizabeth Bandeen, Barbara Brink, Monica Mauti, Roberto Tecchio, Tom Weaver, Kate and Geoffrey Weaver, Barbara Taylor and Norma Clarke, Jane Brodie, Alison Burt, Peter Wilson, James Norton, Brenda Smith, Jackie Jackson, Caroline Palmer, Penny Treadwell, Amy de la Haye.

The exhibition and its catalogue are dedicated to Adam Phillips and to our daughter Marianne.

Judith Clark
London, 2004

The exhibition at MoMu was organised by the Executive Board of the Council of the Province of Antwerp.

Board	Provinciebestuur Antwerpen
Provincial Governor	Camille Paulus
Provincial Recorder	Danny Toelen
Deputies	Ludo Helsen, Jos Geuens, Frank Geudens, Martine De Graef, Marc Wellens, Corry Masson
Director of the Department of Culture	Peter De Wilde

MoMu:	
Director	Linda Loppa
Exhibition Policy	Kaat Debo
Communication	Valérie Gillis
Production manager	Annelies Verstraete
Conservation	Ellen Machiels, Erwina Sleutel, Griet Kockelkoren
Education	Frieda de Booser
Production scenography	Ercola – Decor Atelier
Lighting	Alain Jonghen
Photography installation	Ronald Stoops

ModeMuseum would especially like to thank:
The London College of Fashion, particularly Sandra Holtby, and the AHRB for their support of this project. Ruben Toledo, Yuri Avvakumov, Caroline Evans, Naomi Filmer. Charlie Smith, Susan McCormack, Lauren Parker, Louise Shannon, Mary Butler, Geoff Barlow. The whole team at MoMu. Press Agent At Large (Paris).

ModeMuseum and the V&A would like to thank the lenders to the exhibition:
Christian Lacroix (Elisabeth Bonnel); Maison Martin Margiela (Roxane Danset, Peggy Canovas); Hermès (Ina Delcourt, Milène Gozland); Bruno Pieters (Frédérique Pieters); Bernhard Willhelm (Aline); A.F. Vandevorst (Saar Debrouwere); Olivier Theyskens (Nicolas Frontière – Rochas); Dries Van Noten (Bache Jespers, Joeri Meij); Jean-Paul Gaultier (Milène Lajoix); Kathleen Missotten (Vincent); Dai Rees; Boudicca (Meg van Heck); Helmut Lang (Tanya Ruhnke); Robert Cary-Williams (Horng Yih Wong – Concrete PR London); Walter Van Beirendonck; Dirk Van Saene; Hamish Morrow (Louise Dalton); Russell Sage; Shelley Fox; Simon Thorogood; Viktor & Rolf (Bram Claassen); Ann Demeulemeester (Anne Chapelle, Stefan Verresen); Veronique Branquinho (Raïssa Verhaeghe); Jean-Claude Madrange; Arkadius; Louis Vuitton (Pieter Waller).

Groninger Museum; Speelgoedmuseum Mechelen (Marc Wellens); Musée du Jouet Bruxelles.

Concept and design development of Spectres supported by the AHRB, as part of the 'Fashion and Modernity Project' at Central Saint Martins College of Art and Design and London College of Fashion (both colleges of the University of Arts London).

A·H·R·B
arts and humanities research board

UNIVERSITY OF THE ARTS
LONDON **LONDON COLLEGE OF FASHION**
CAMBERWELL COLLEGE OF ARTS CENTRAL
SAINT MARTINS COLLEGE OF ART AND DESIGN
CHELSEA COLLEGE OF ART AND DESIGN
LONDON COLLEGE OF COMMUNICATION

FORTIS

Thanks also to: Thalys, Swarovski, Scapa, Weekend Knack, Hitachi, VLM, Hilton, Levis – Akzo Nobel

First published by

V&A Publications
160 Brompton Road
London SW3 1HW
www.vam.ac.uk

in association with ModeMuseum Province of Antwerp (MoMu)

Distributed in North America by Harry N. Abrams, Inc., New York

The exhibition is curated by Judith Clark, V&A/London College of Fashion Fellow in
Contemporary Fashion, and was initiated by ModeMuseum Province of Antwerp (MoMu).

ISBN 1 85177 453 X (Europe)
ISBN 1 85177 456 4 (UK, USA and rest of world)

Library of Congress Control Number 200411931

Design: Charlie Smith Design
Project management: Geoff Barlow
Printed in Italy by Conti Tipocolor, Florence

Front cover illustration:
Phantasmagoria: The Amazing Lost and Found.
Malign Muses: When Fashion Turns Back, MoMu Antwerp, 18/9/2004–30/1/2005.
(Black dress): Christian Dior Evening Dress, silk faille with tulle petticoat, 1955.
V&A, T.118-1974

Back cover illustration:
Phantasmagoria: The Amazing Lost and Found.
Malign Muses: When Fashion Turns Back, MoMu Antwerp, 18/9/2004–30/1/2005.
Inside view of the magic lantern.